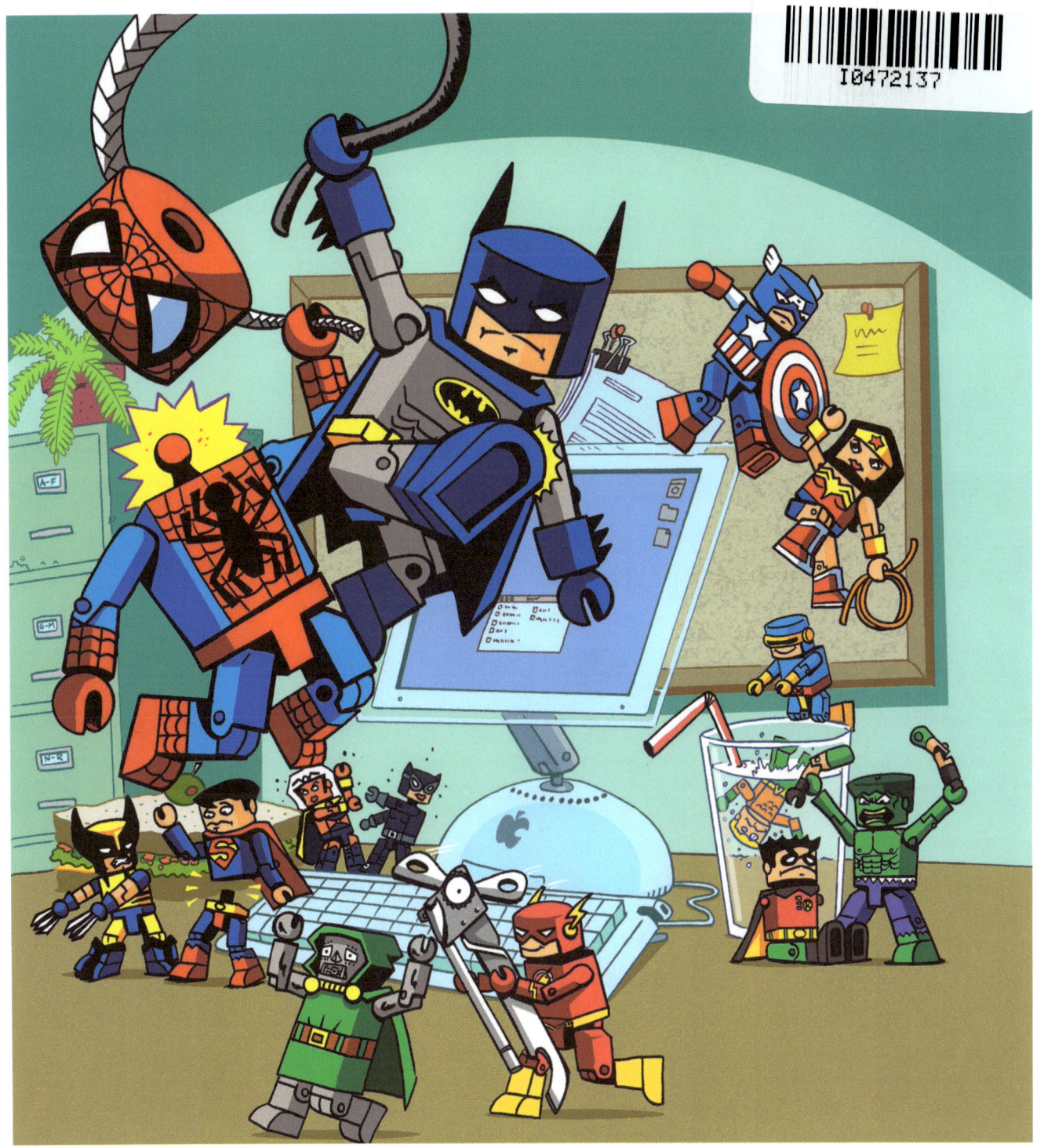

ONE WITH EVERYTHING
Illustrations by Ryan Dunlavey

This book is a showcase of works created by artist Ryan Dunlavey (b. 1971 -). All trade names, product names, trademarks and copyrights of third parties, including any trademarked and/or copyrighted characters are referenced or represented for editorial "fair use" purposes only or for the purposes of parody and/or identification (where applicable). No sponsorship, endorsement or affiliation by or with those third parties exists or should be implied. Published by Evil Twin Comics, 262 5th Avenue, 2nd floor, Brooklyn, NY 11215. All contents ©Ryan Dunlavey unless otherwise indicated. None of the contents of this publication may be reprinted without the permission of Evil Twin Comics, with the exception of artwork samples used for review purposes. All rights reserved. First printing, April 2012.

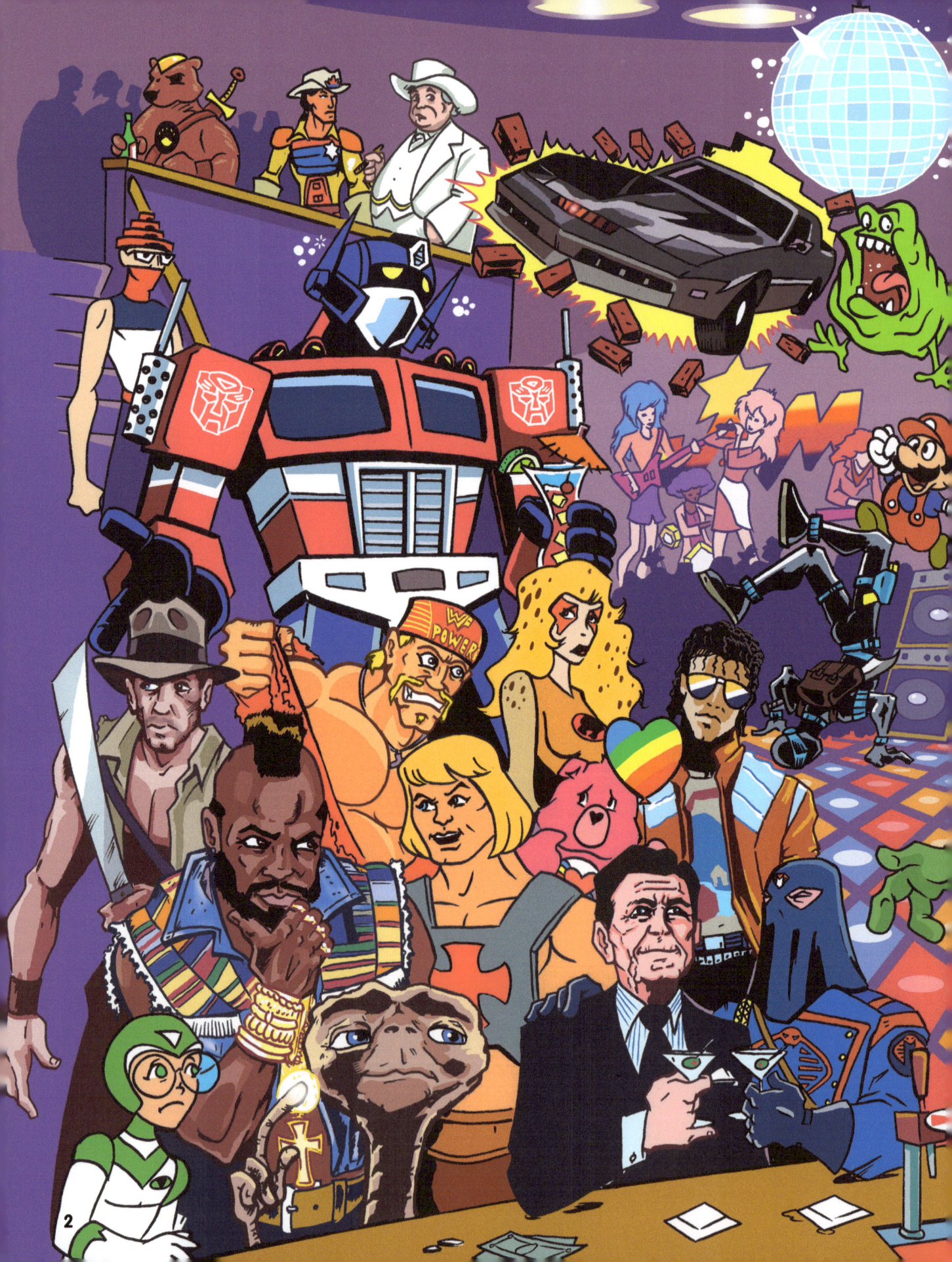

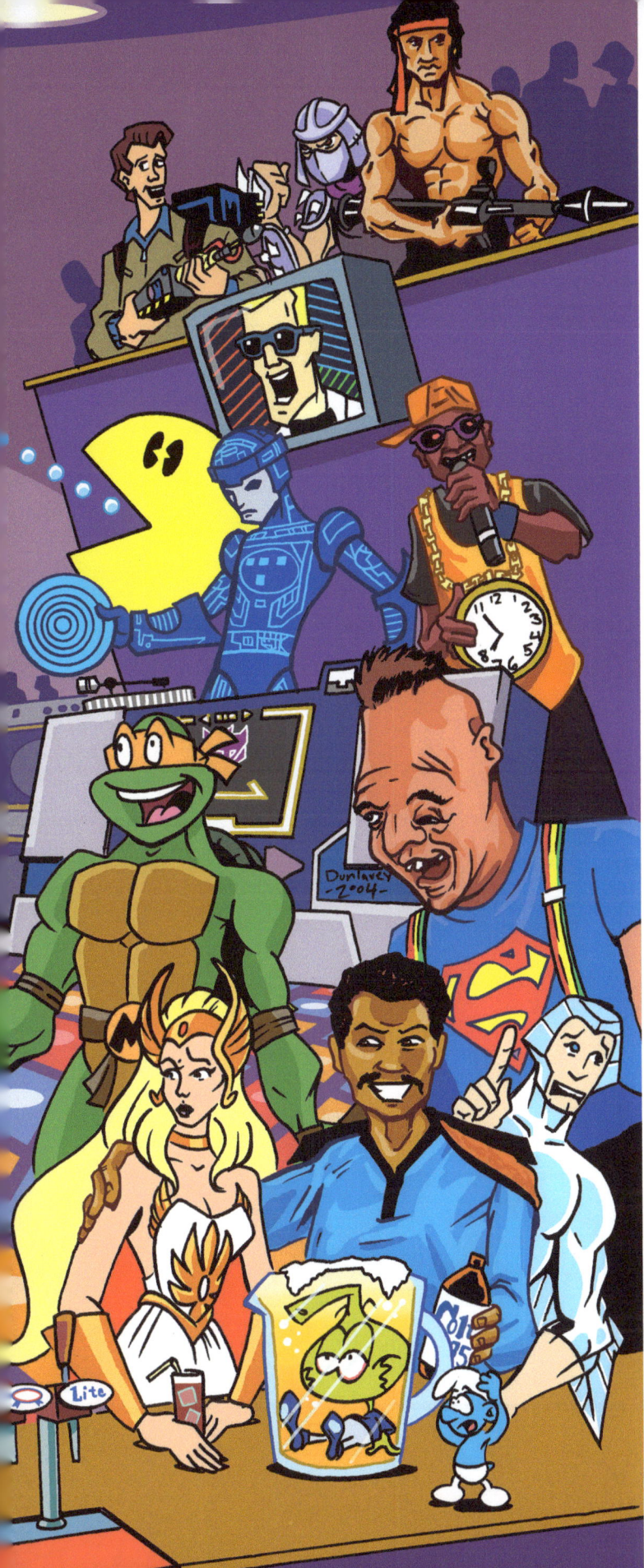

Contents

1	Toy Fight!
2	The '80s Strike Back
4	Adult Swim Pool Party
6	Dead Man's Party
7	Black Wedding
8	Irish Wake
10	Cartoon Beach Party
11	Pop
12	Another Dead Superhero Thing
14	Limbo Lounge
16	The Geek 100
18	100 Greatest Cartoon Characters
20	Where's Guy Gardner?
21	Process
22	Hot For Teacher
24	Welcome to Megoville
26	Know Your Ninjas
28	Planet Hulk: The Home Game!
30	Star Trekkin
32	D-List Super Villain Funeral
34	Megoville: The Game
35	Fans
36	Pokemon vs Sailor Moon
37	Super Sunday Funnies
43	Seuss Does Superheroes
44	Black Manta
46	Action Philosophers
48	Hispanic Batman Team-Up
49	Covered: G.I. Joe #1
50	Fall of the Hulks: MODOK page 5
51	Galactic Noogie
52	Covered: X-Force #1
54	Sinister Six
55	Comic Con Do's And Don'ts
56	The Doctor Is In, About The Artist

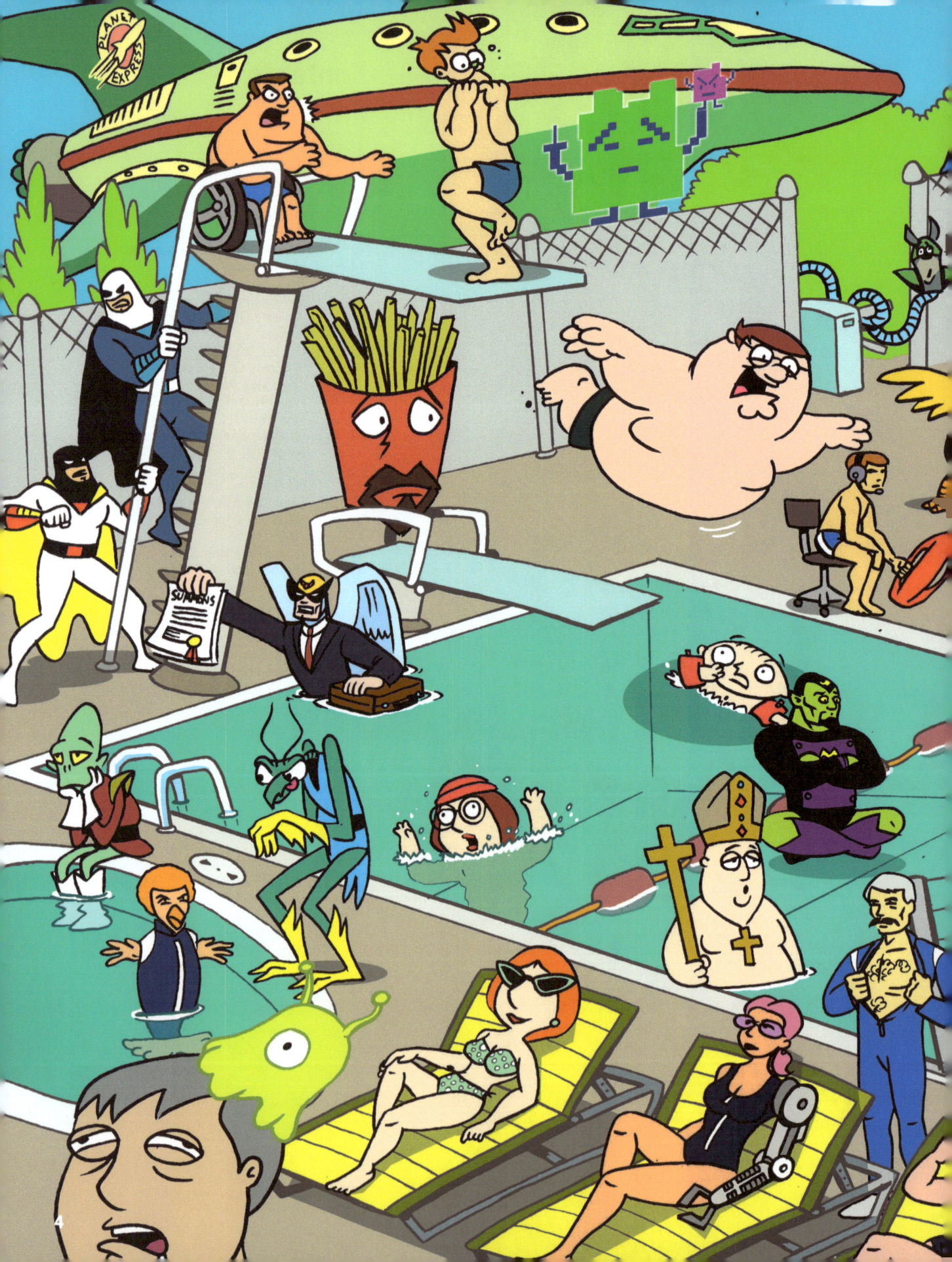

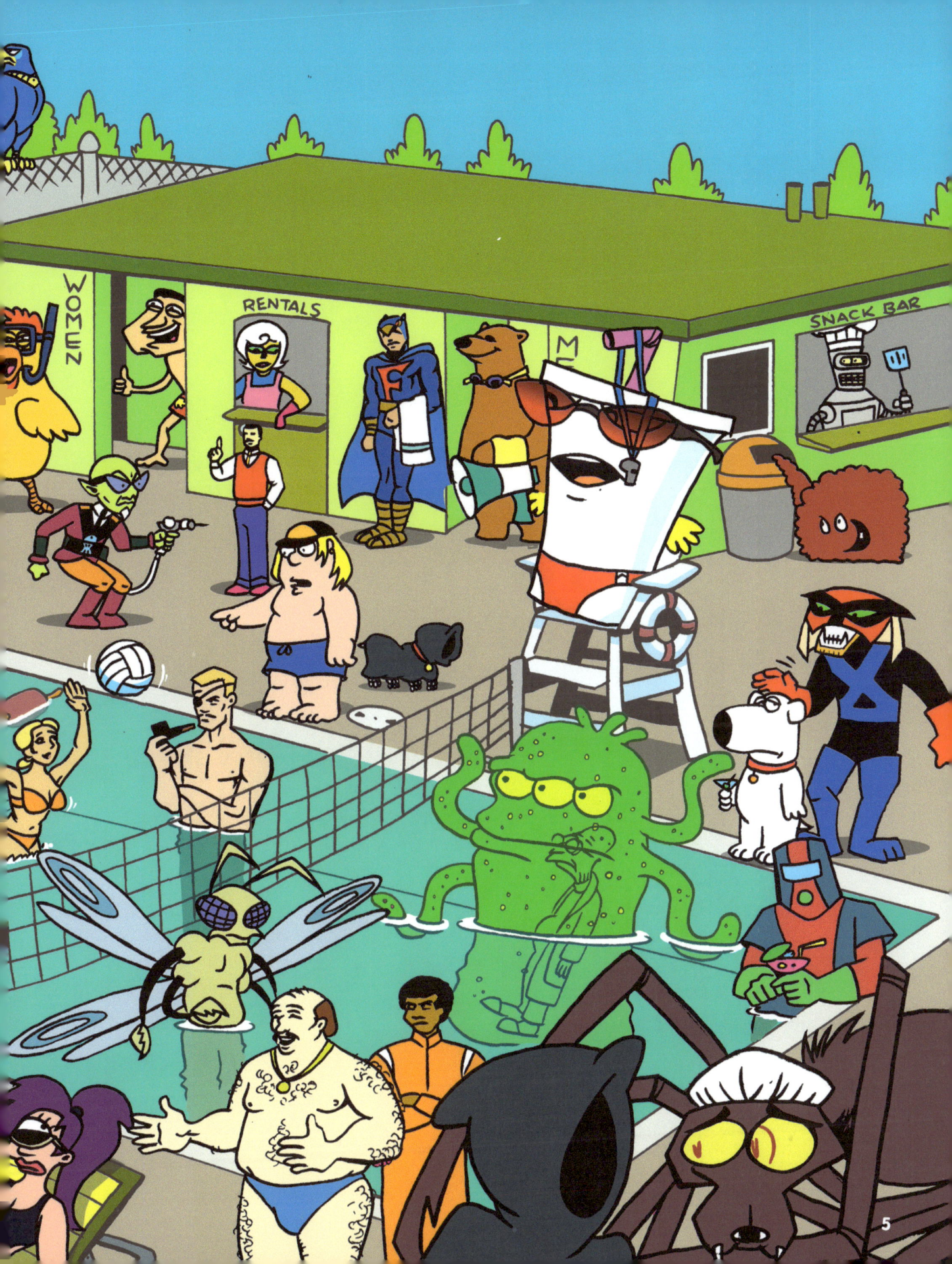

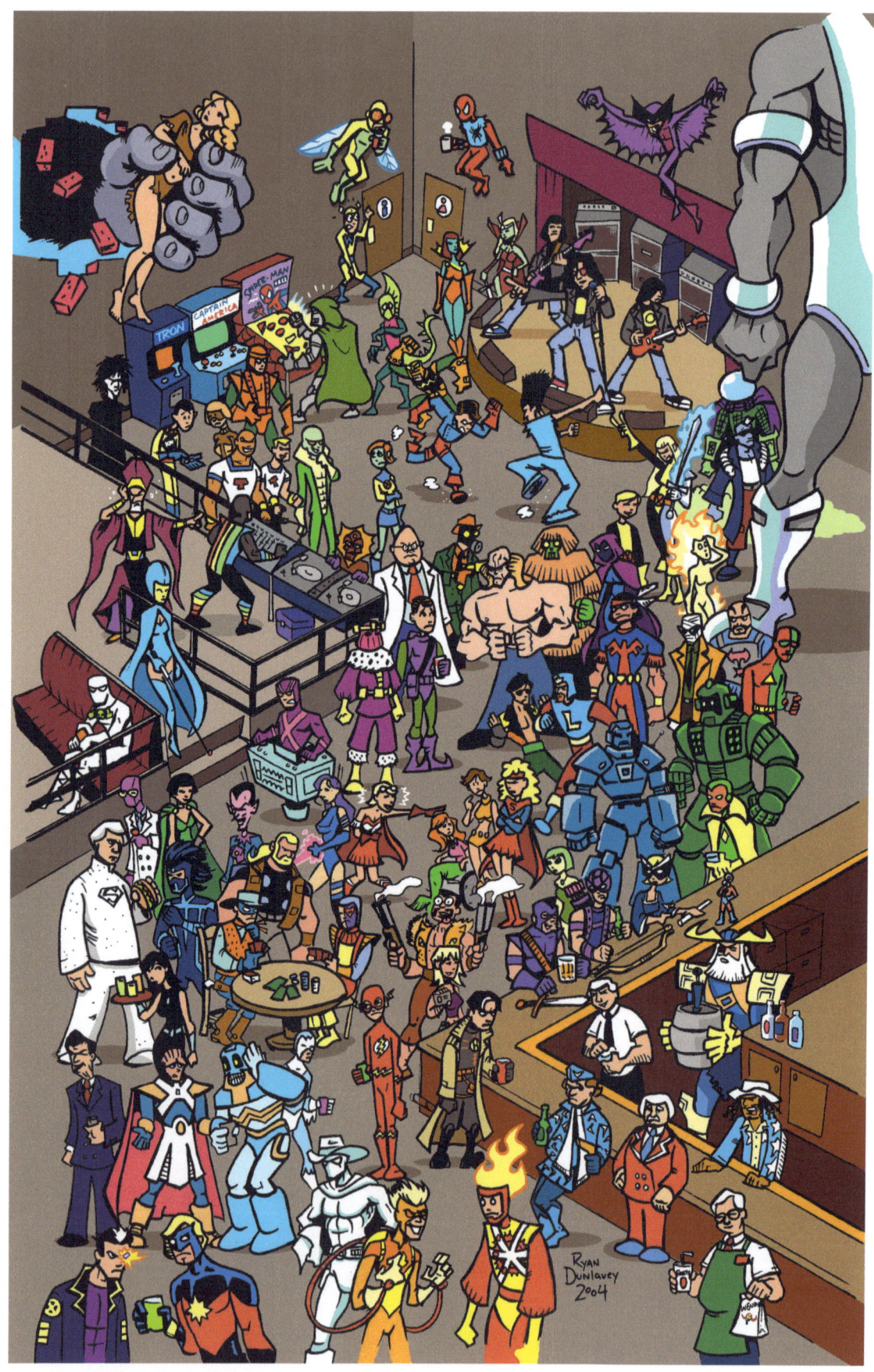

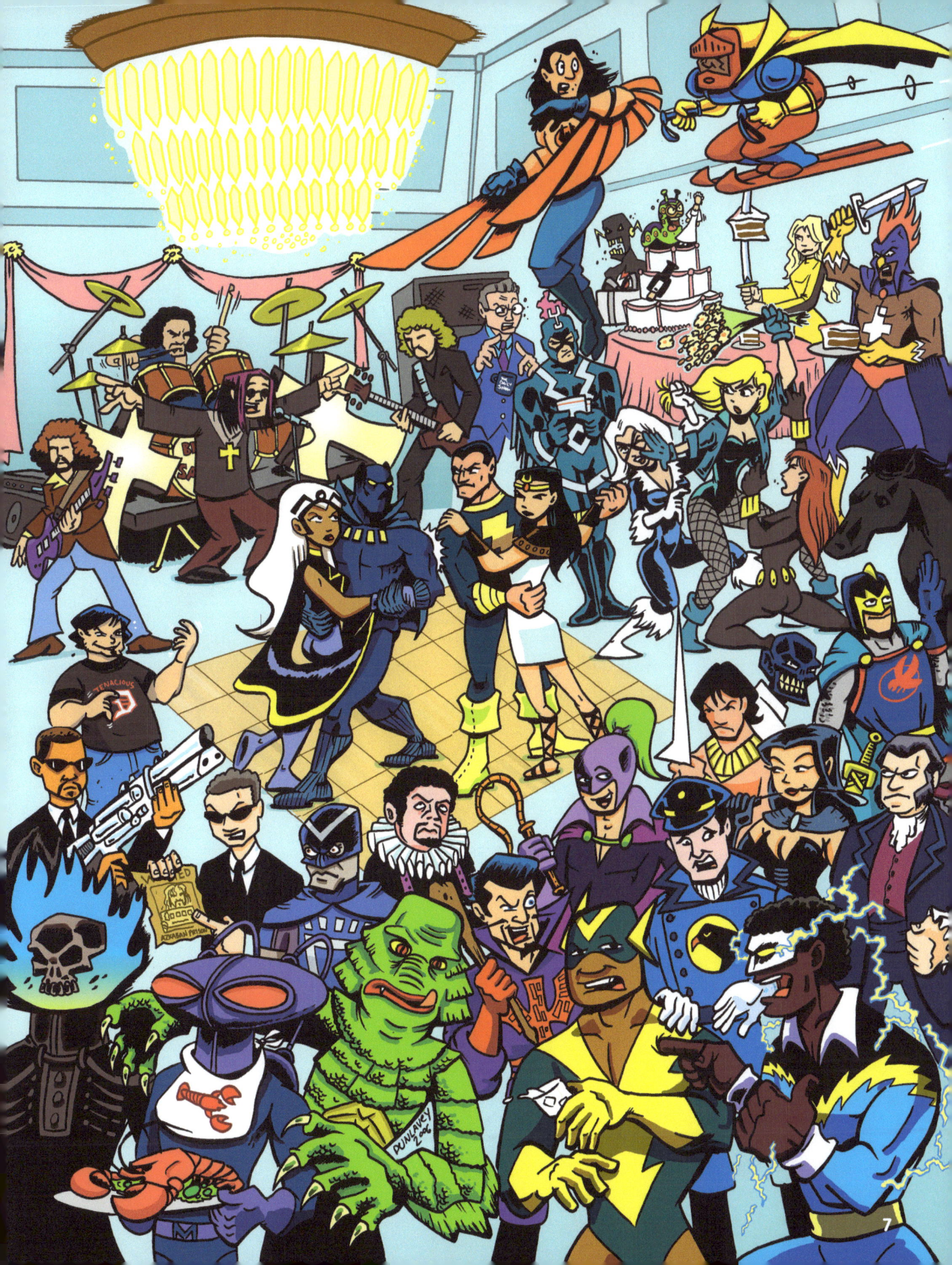

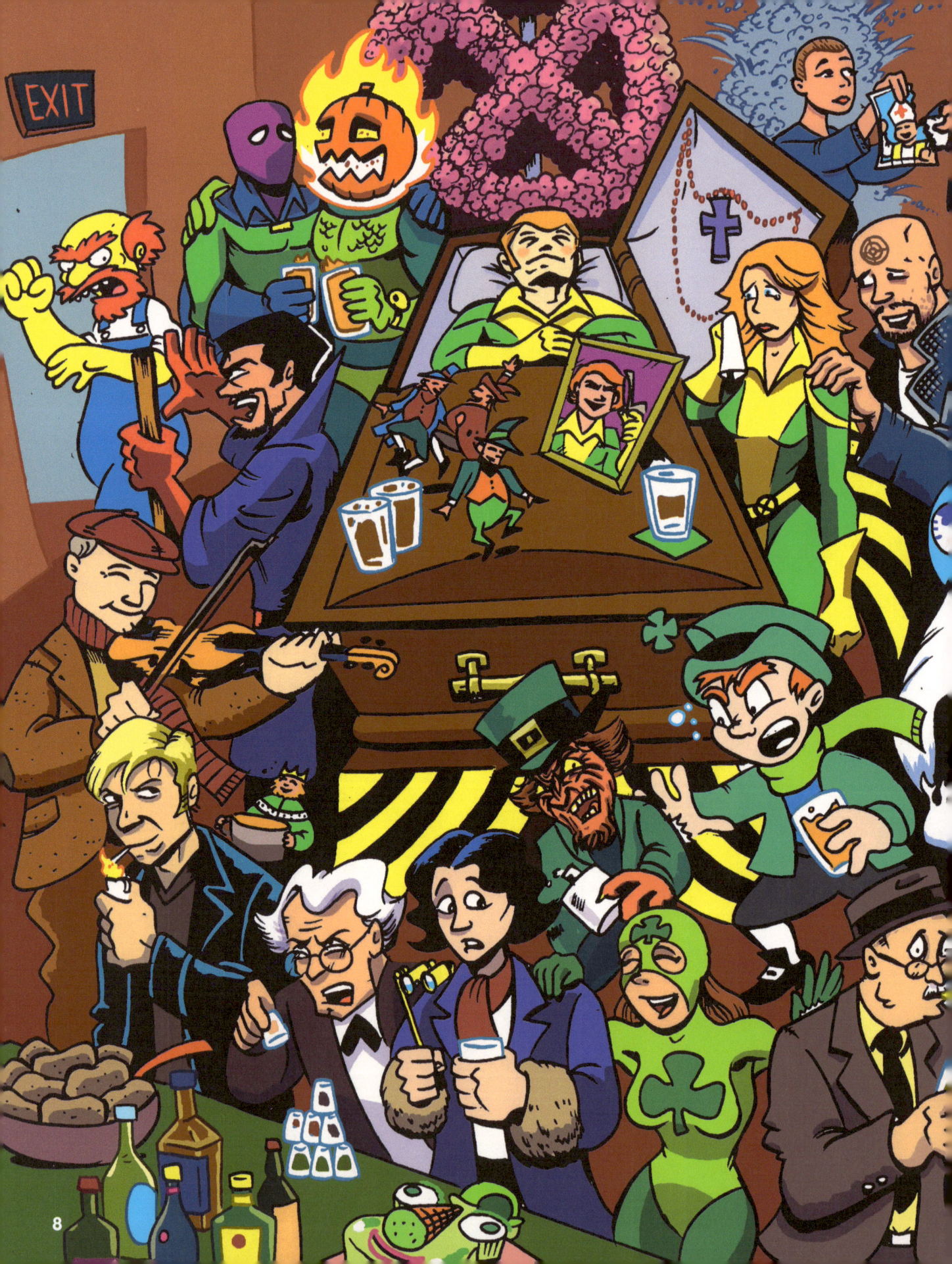

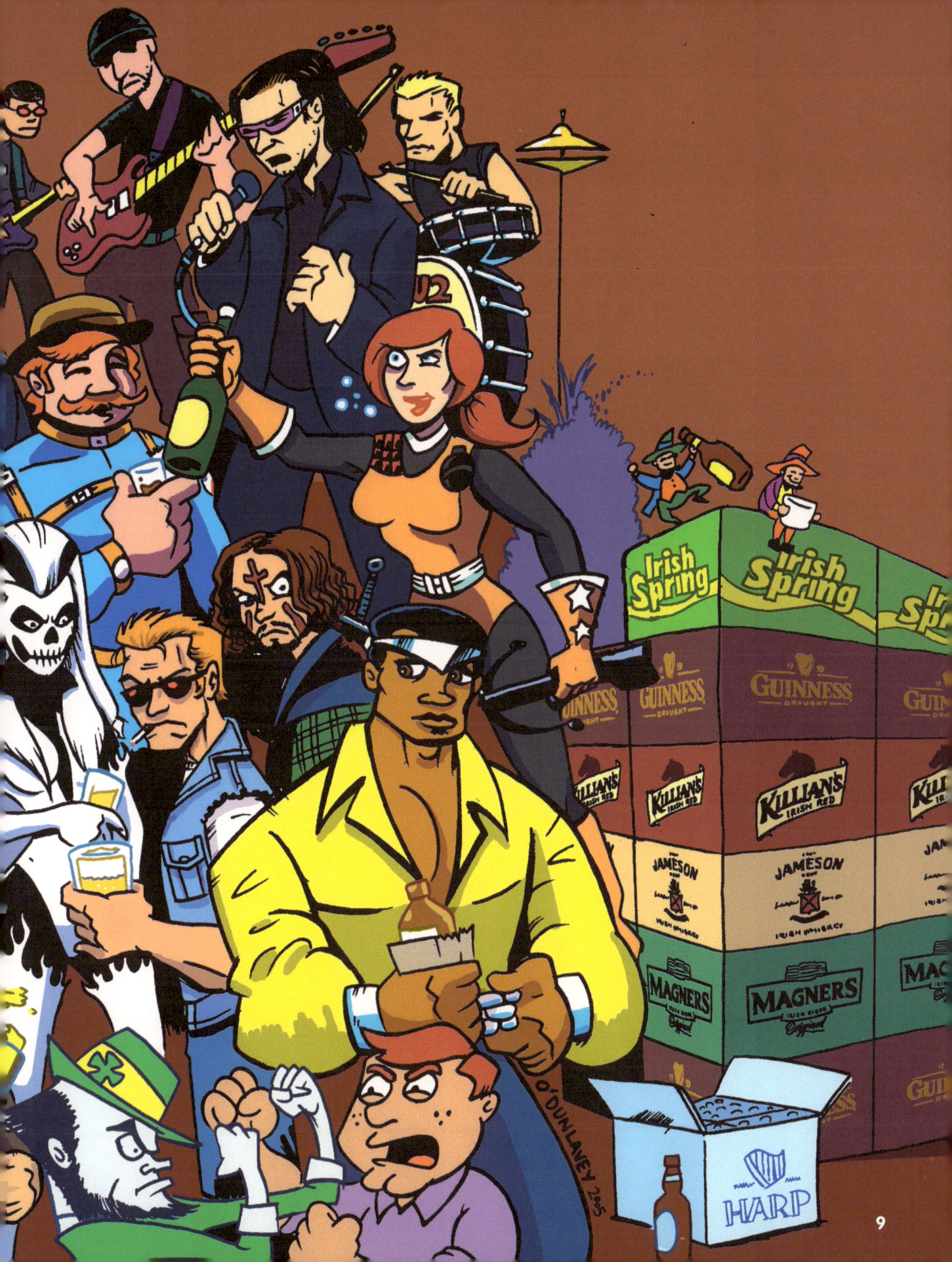

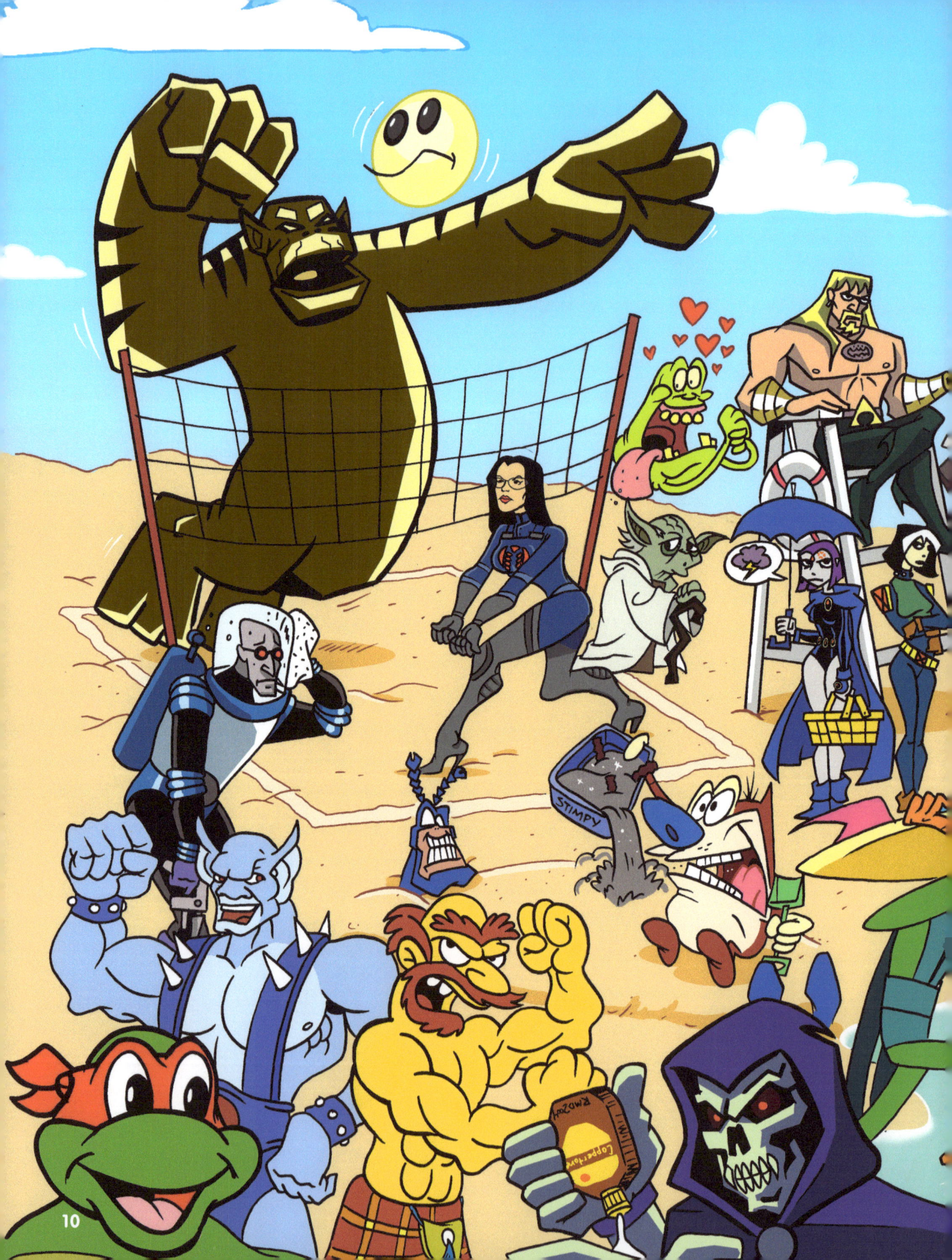

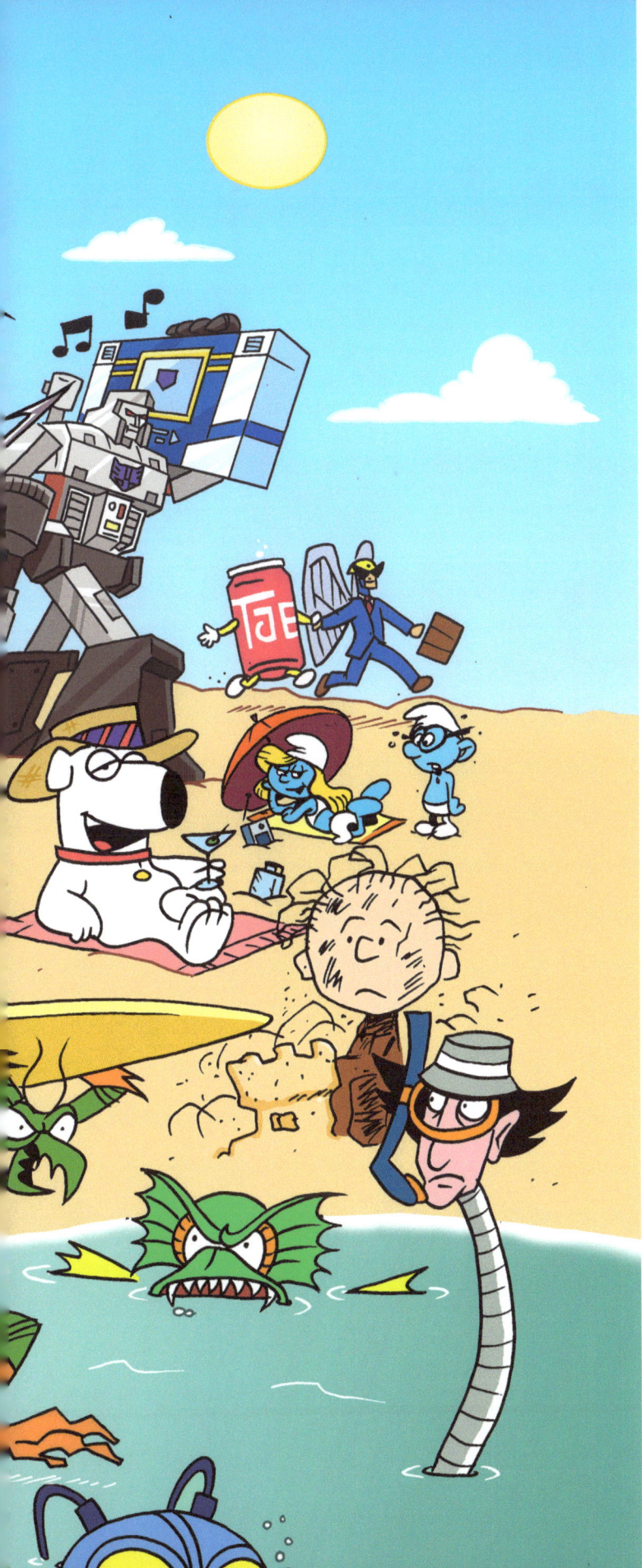

Pop

It's an easy trick to take two or more things that are already beloved by the public and mash them together into something "new". If you're just a little clever about it and are able to execute your idea with a moderate ammount of talent and professional polish, the public will respond positively with either praise or money.

On the flip side, making something wholly original and getting people to like it (or even just to pay attention) is *really* hard, and when you're trying to engage a jaded audience starved for shiny new entertainments, it's a nearly impossible trick to pull off.

As an artist my primary interest has always been in creating my own stories, characters and ideas. It wasn't until I started replicating already famous comic and cartoon creations a few years ago that a larger group of people started to take notice of me and my work. It's a bit of a disappointing situation to me, but I'm still proud of my work here in this book. It was all really fun to draw, and I really like super heros and comic books and science fiction and cartoons too, so I totally understand why people dig this stuff, and I'm glad they do, even if it feels a little dishonest.

So thanks for picking up this book, but please check out some of my other work when you get a chance, ok? You might even like it!

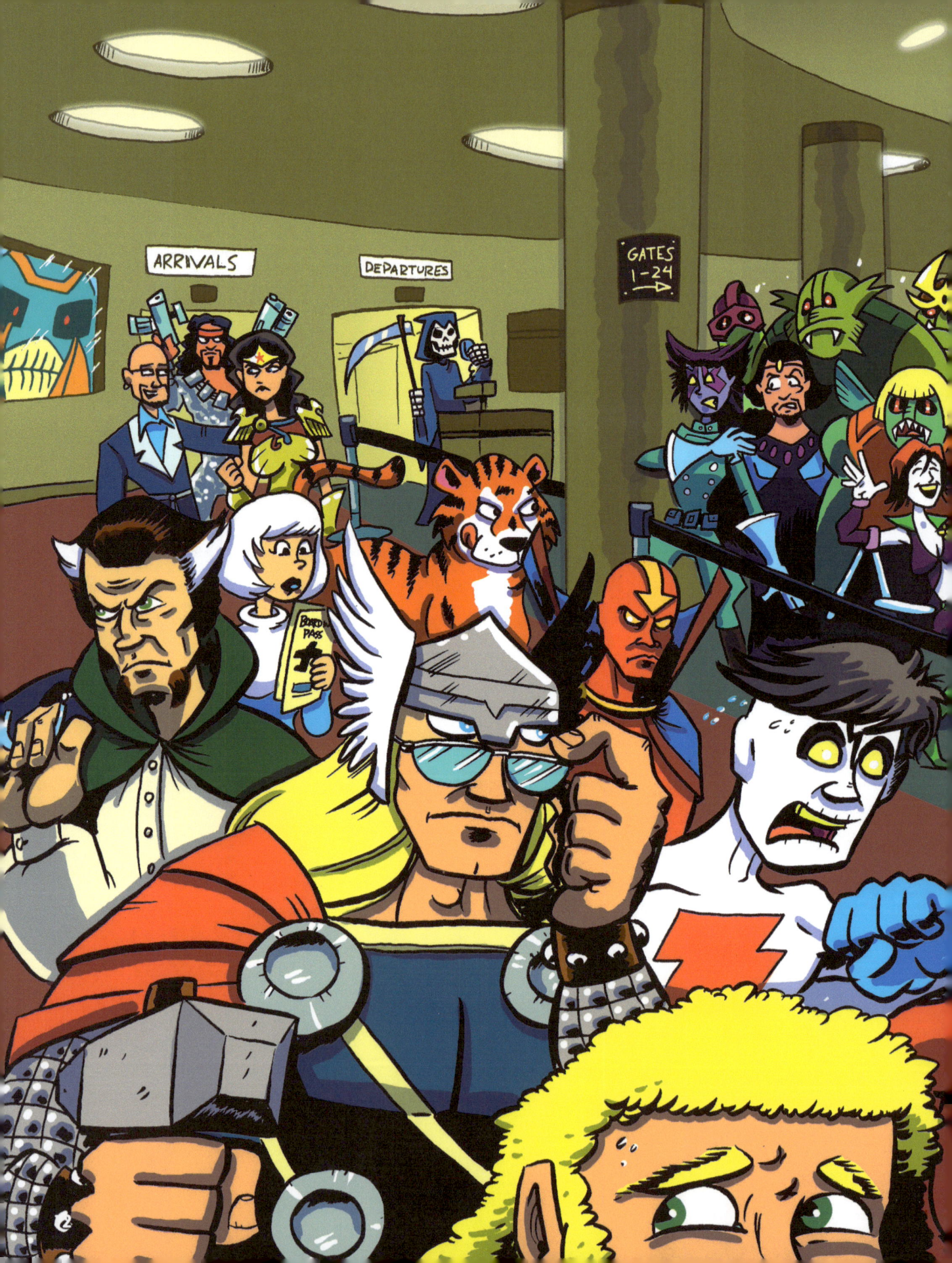

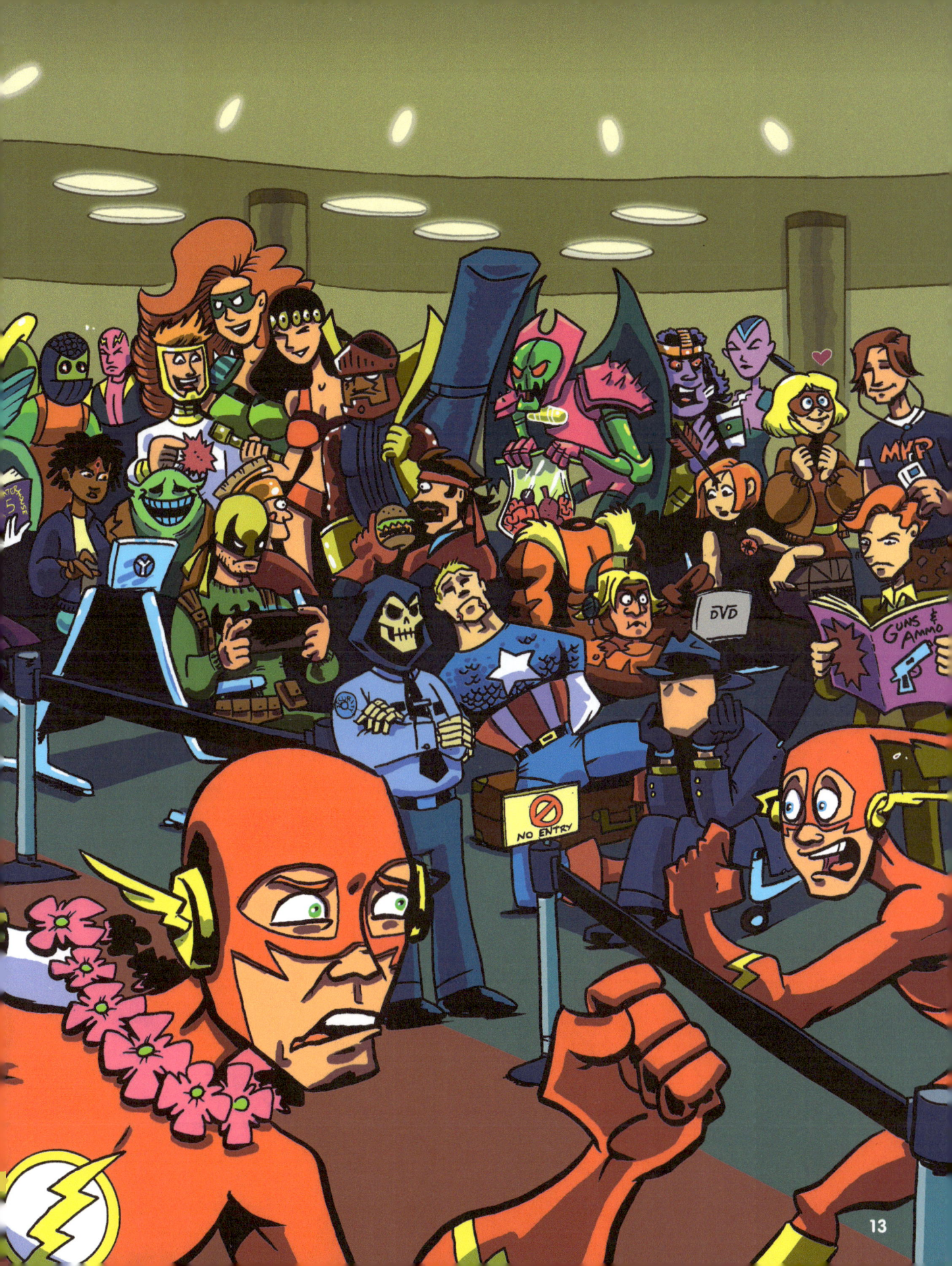

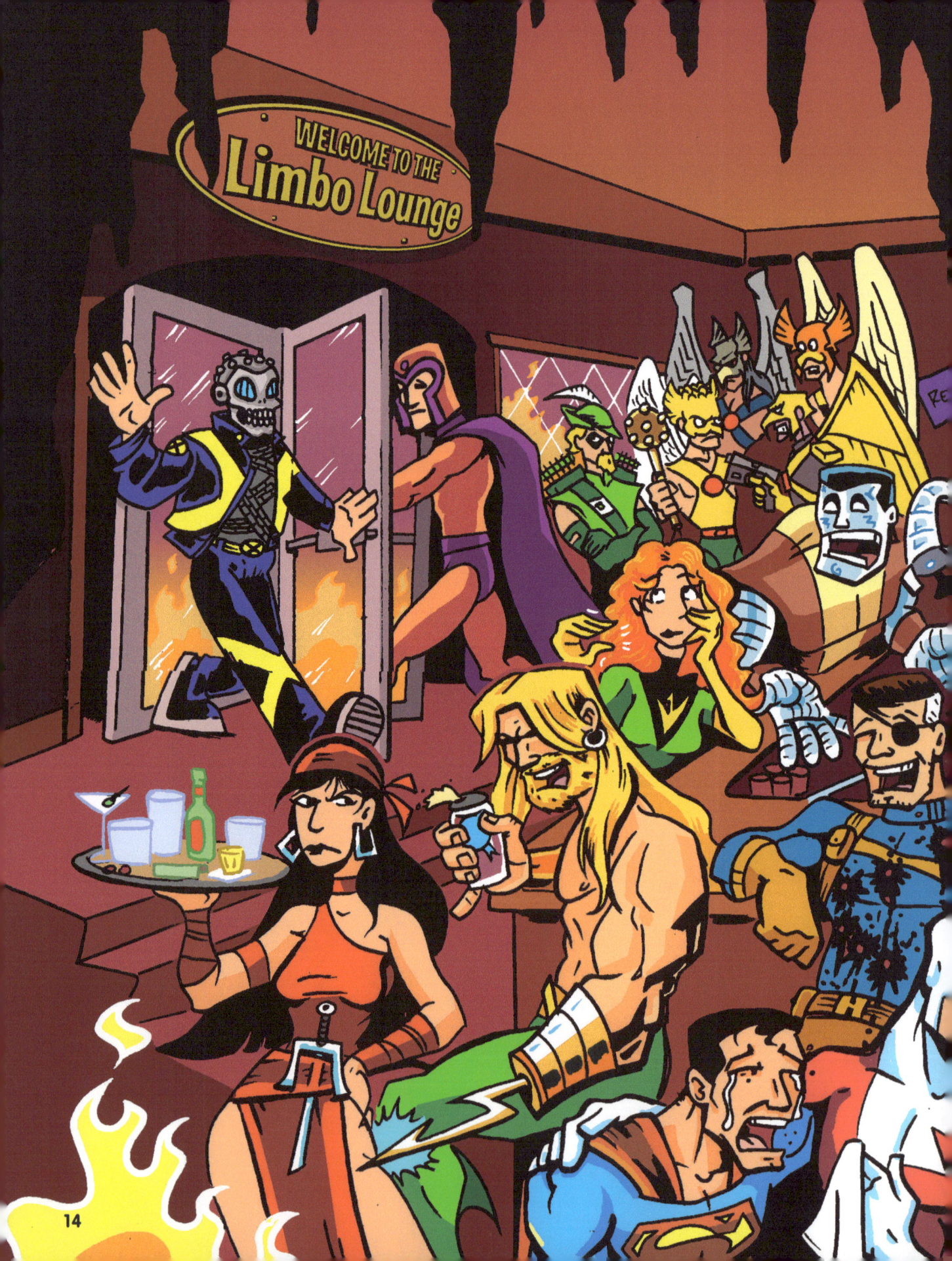

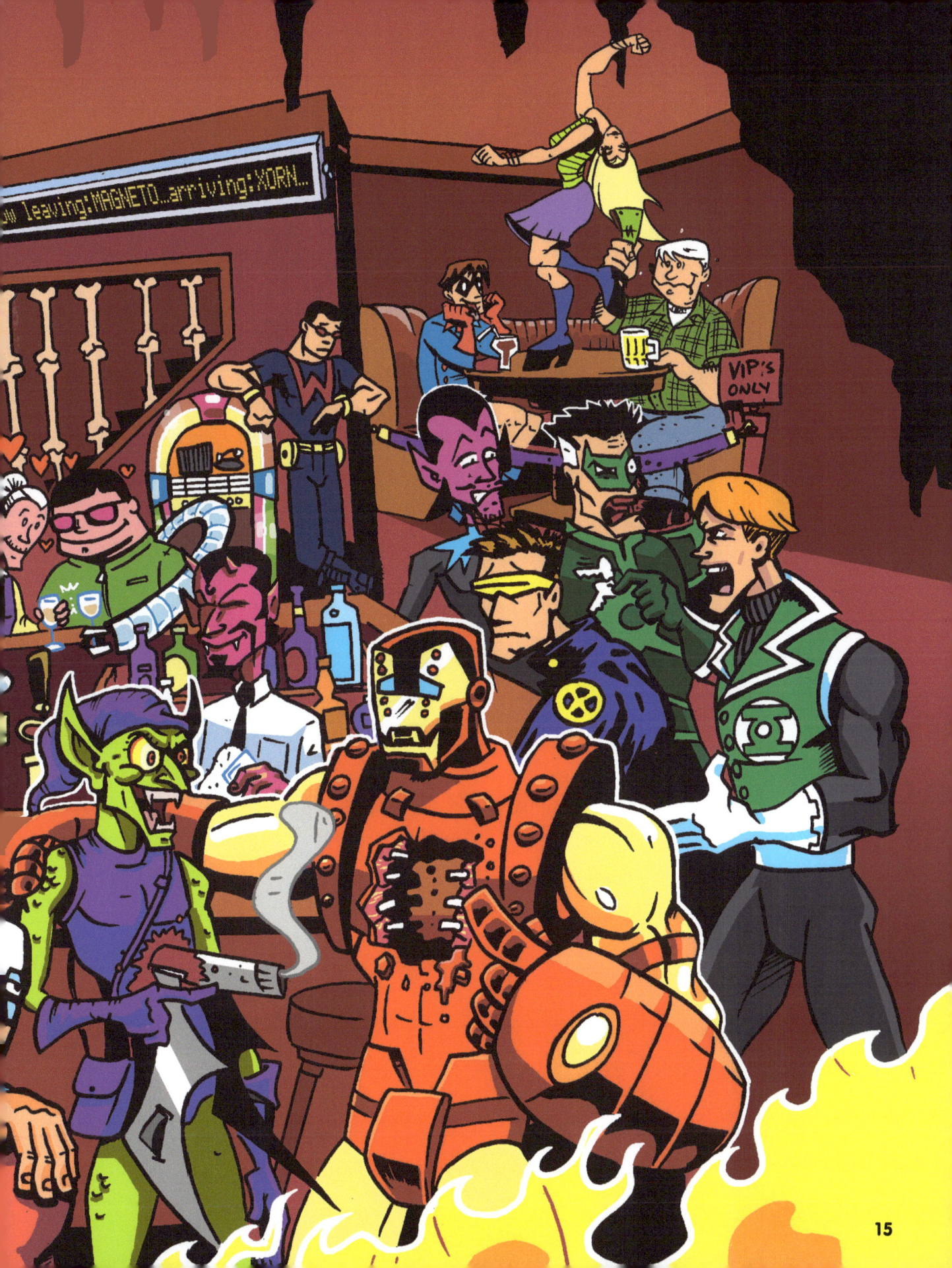

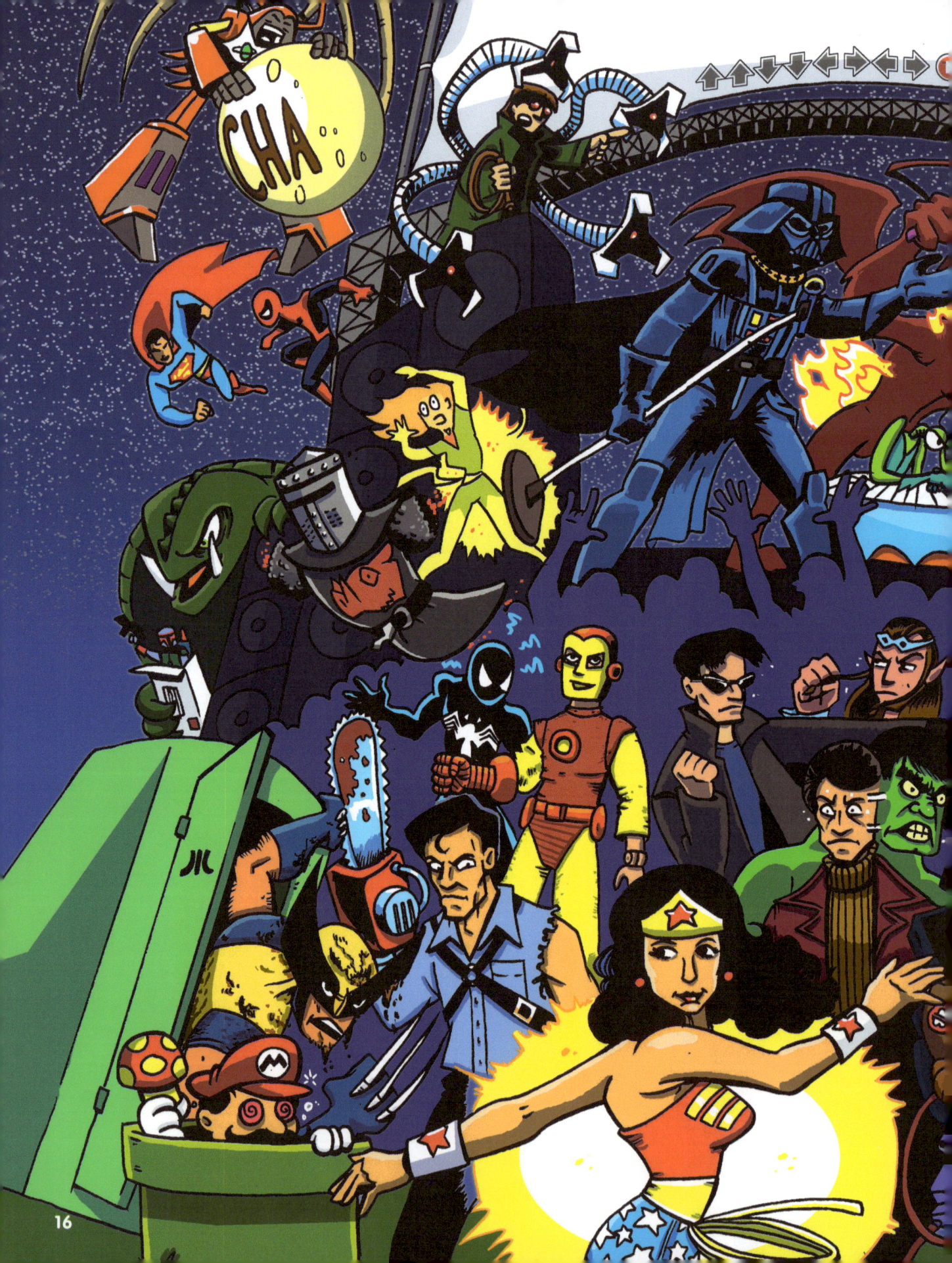

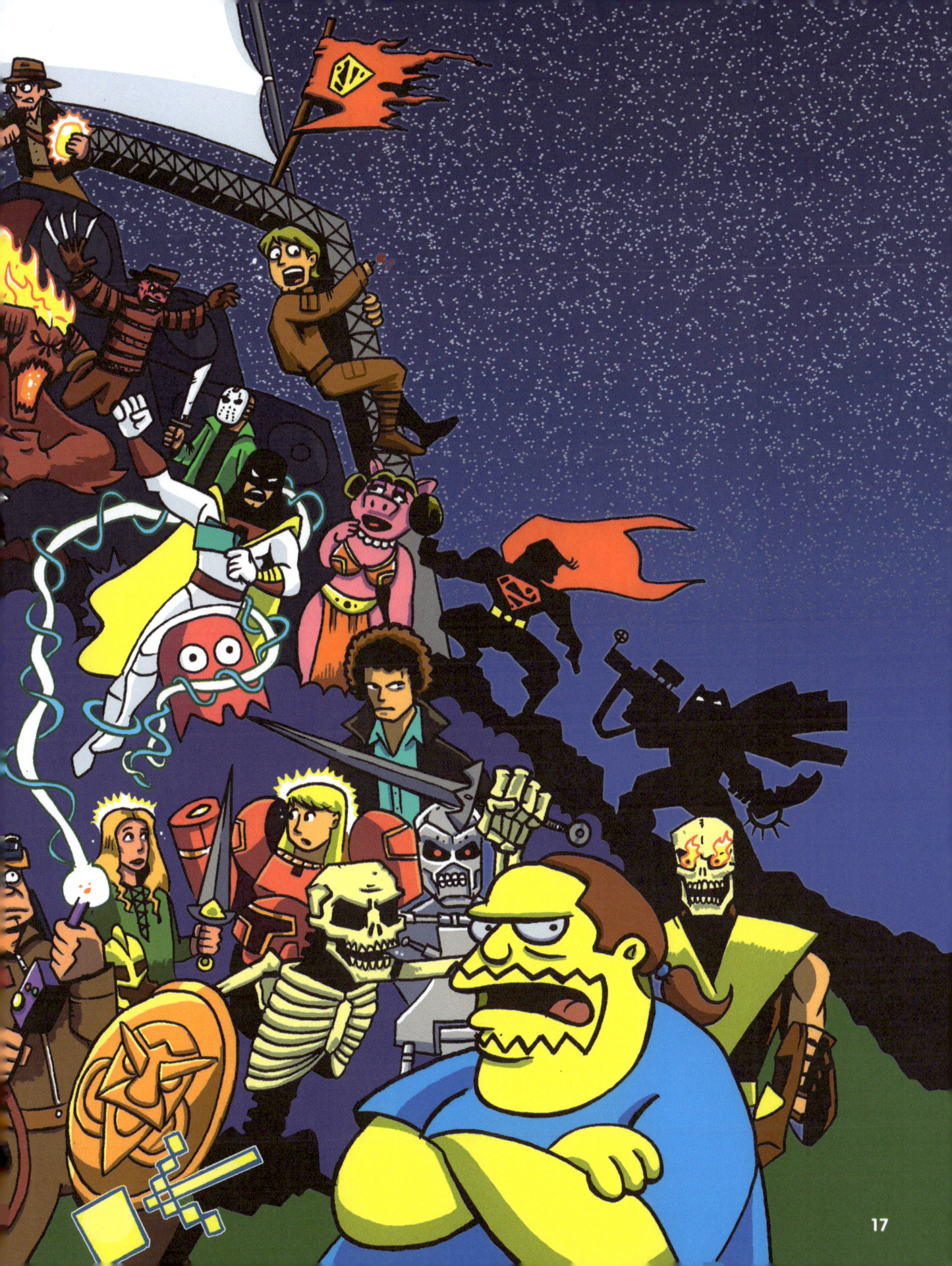

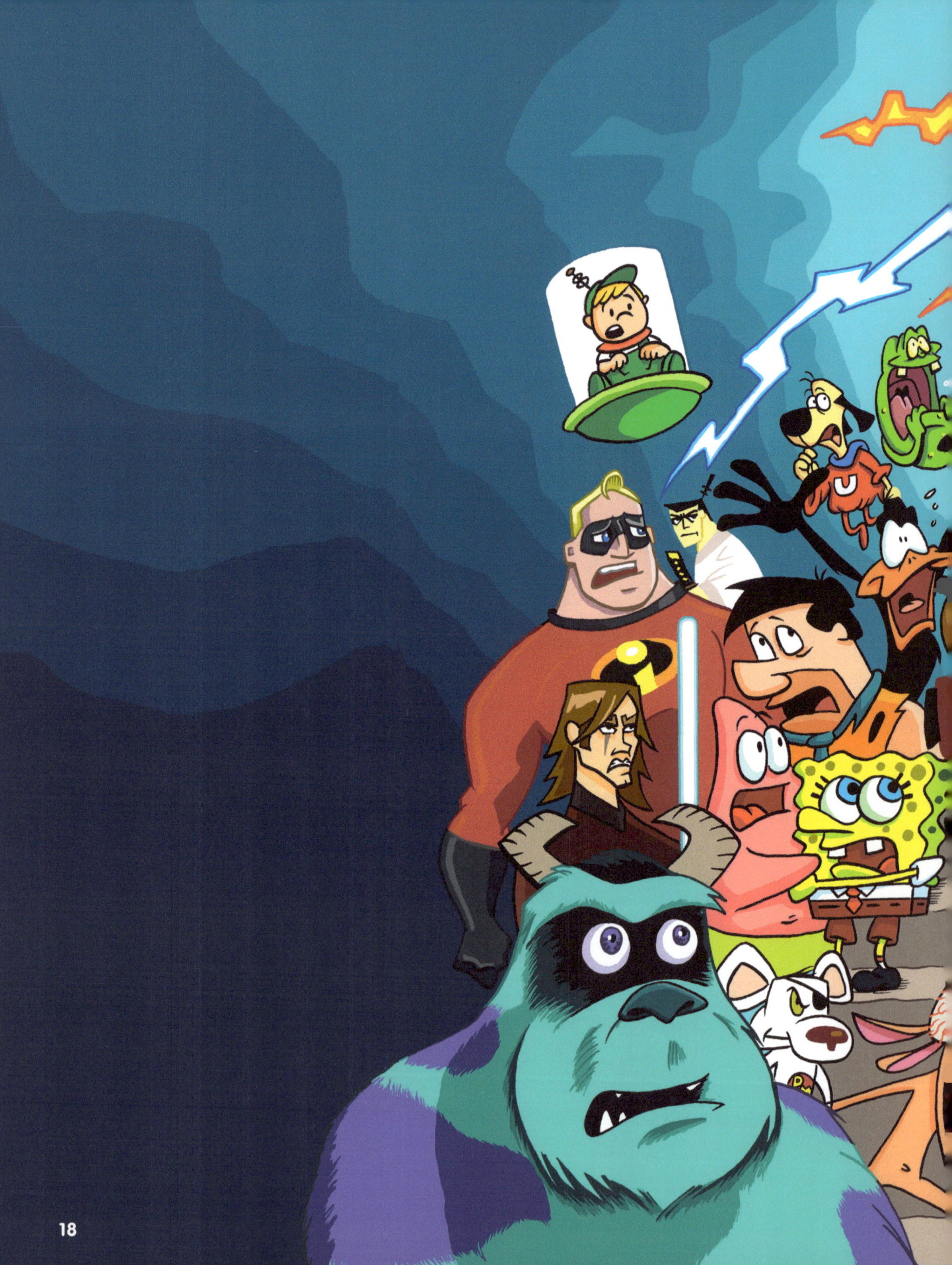

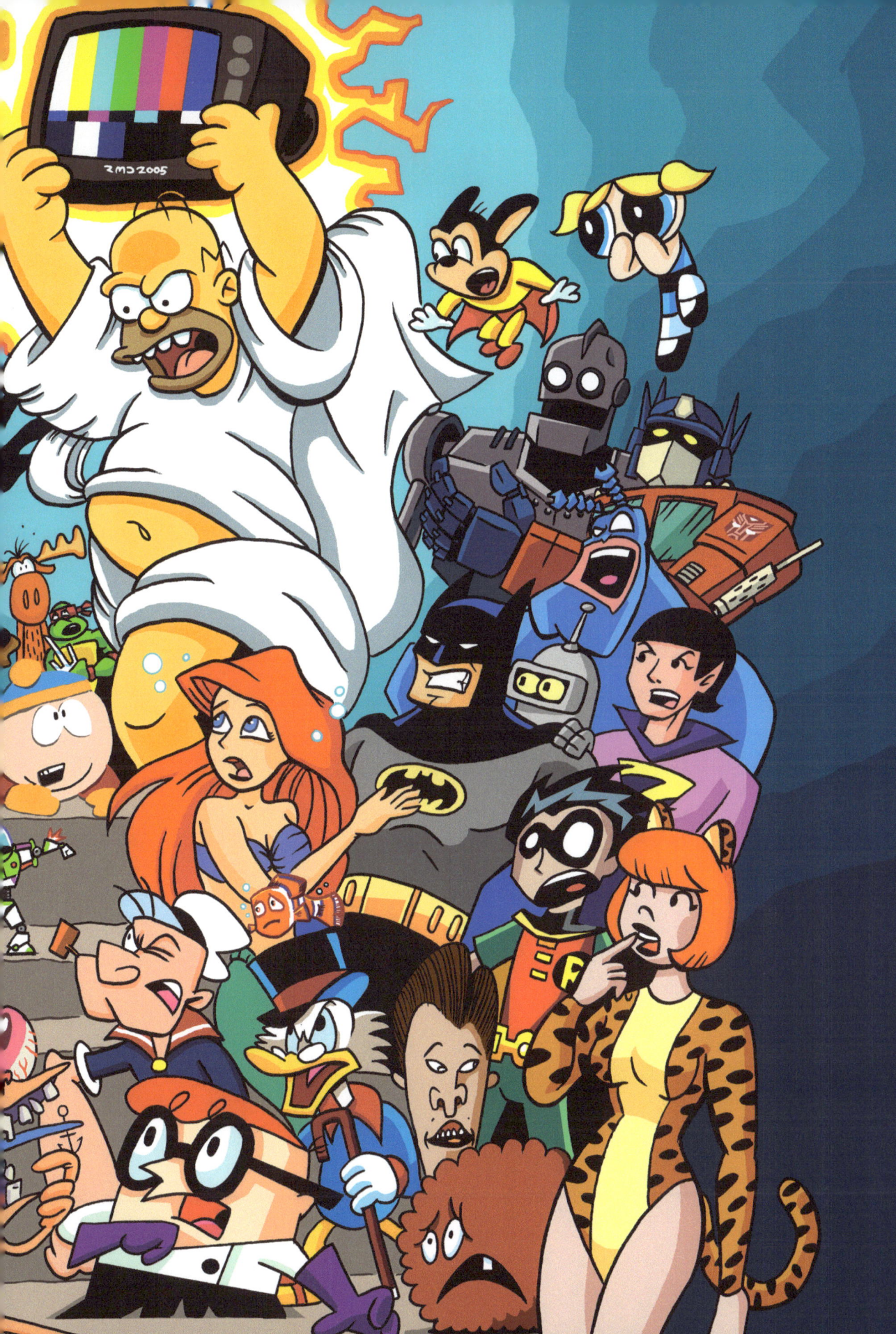

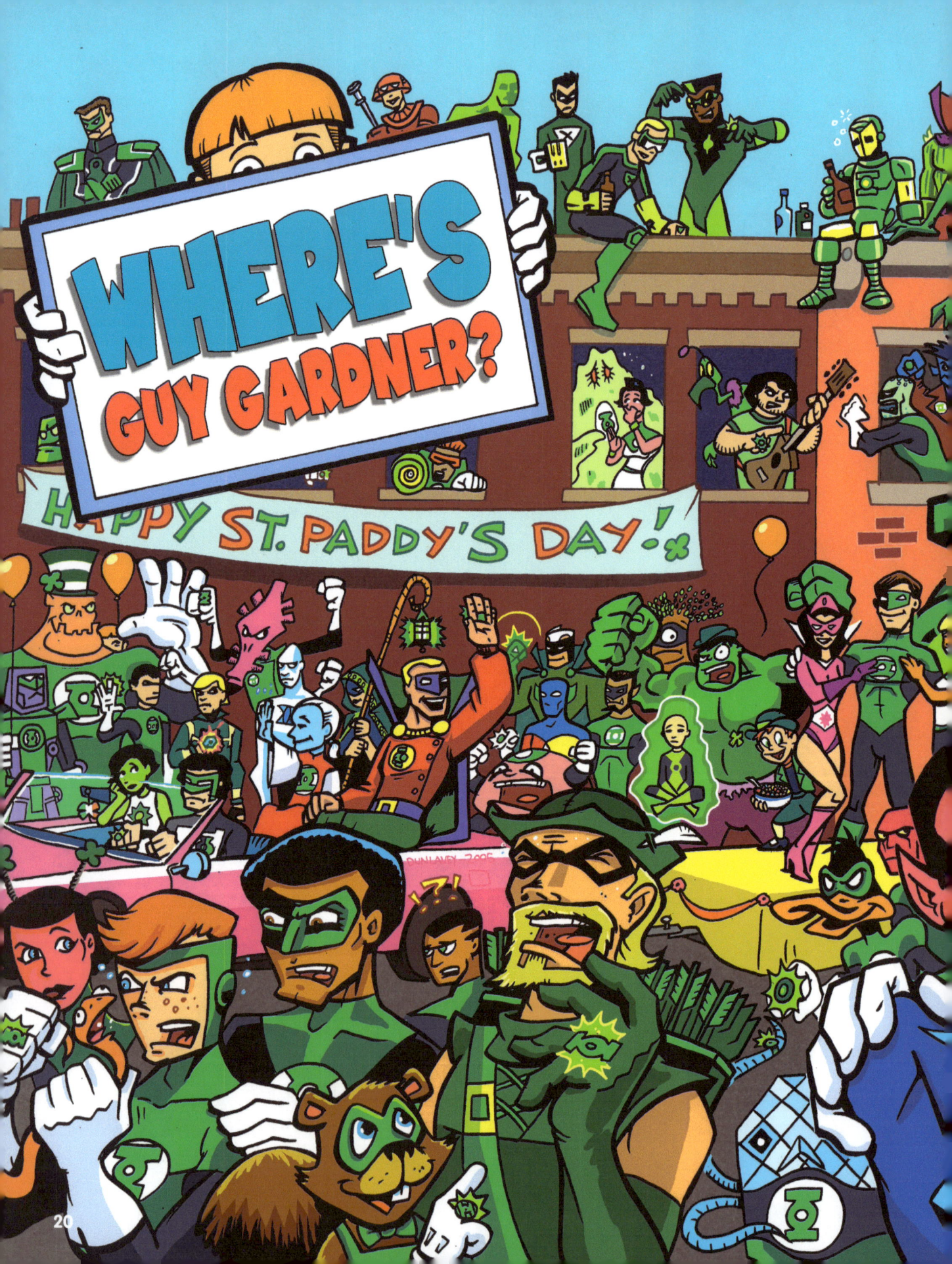

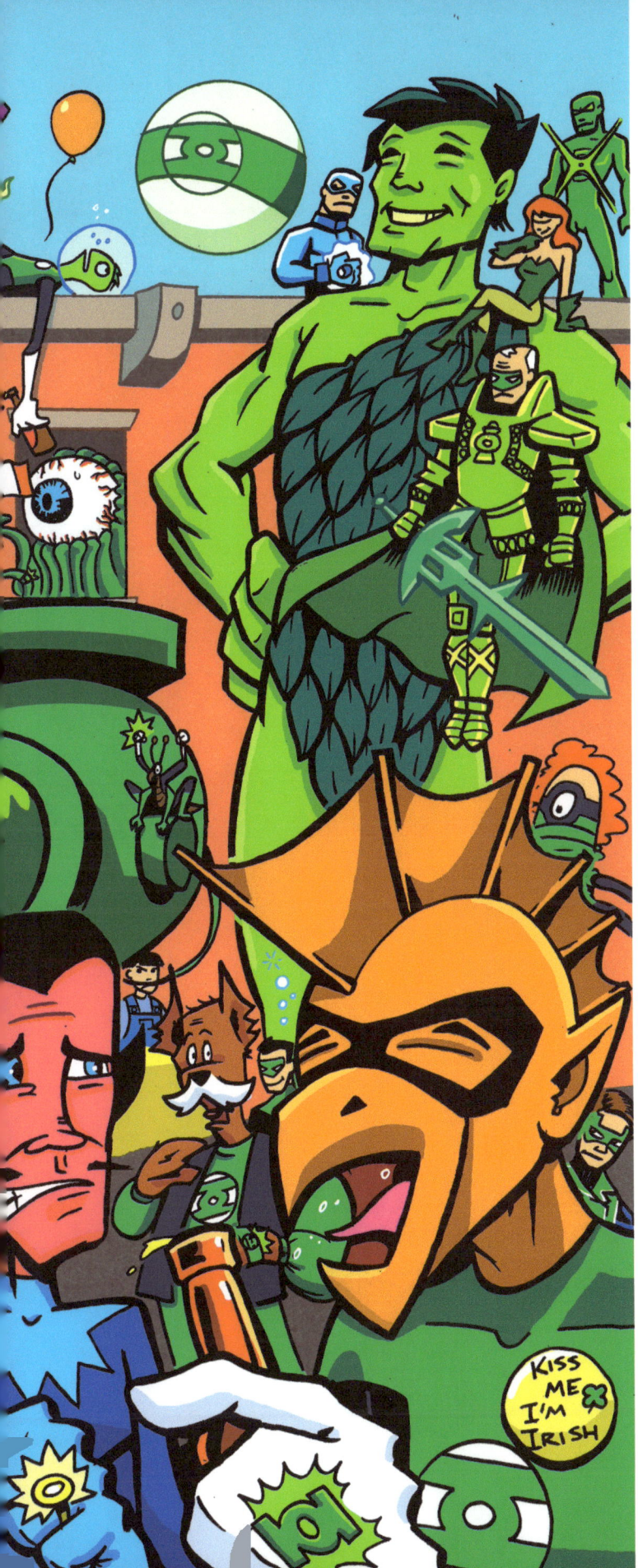

Process

1 - Client gives me a big list of characters.

2 - I decide which I'm going to like drawing the best, or what makes the best gag or visual and then draw that really big in the foreground.

3 - Loosely sketch the background environment.

4 - Come up with some gags for the other characters, draw the best ones medium size behind the big characters.

5 - Draw the rest of the characters on the list really small in the gaps between the big and medium characters.

6 - Finish drawing the background in detail.

7 - Check the character visual details against the accepted style, make changes if necessary.

8 - Ink it.

9 - Color it.

10 - Sleep.

(He's on the far left, mid page, behind the big orange alien in a striped hat. You're welcome.)

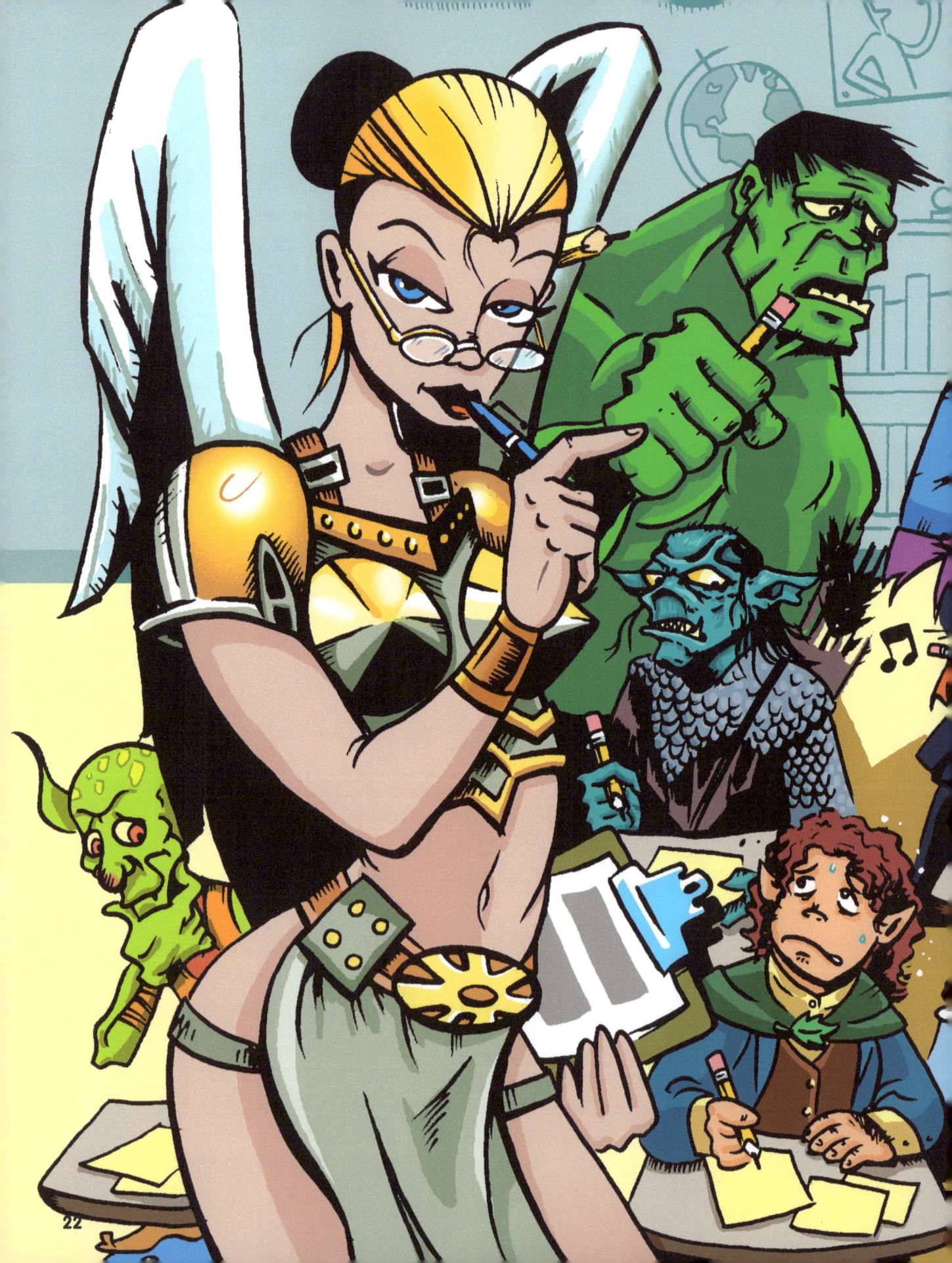

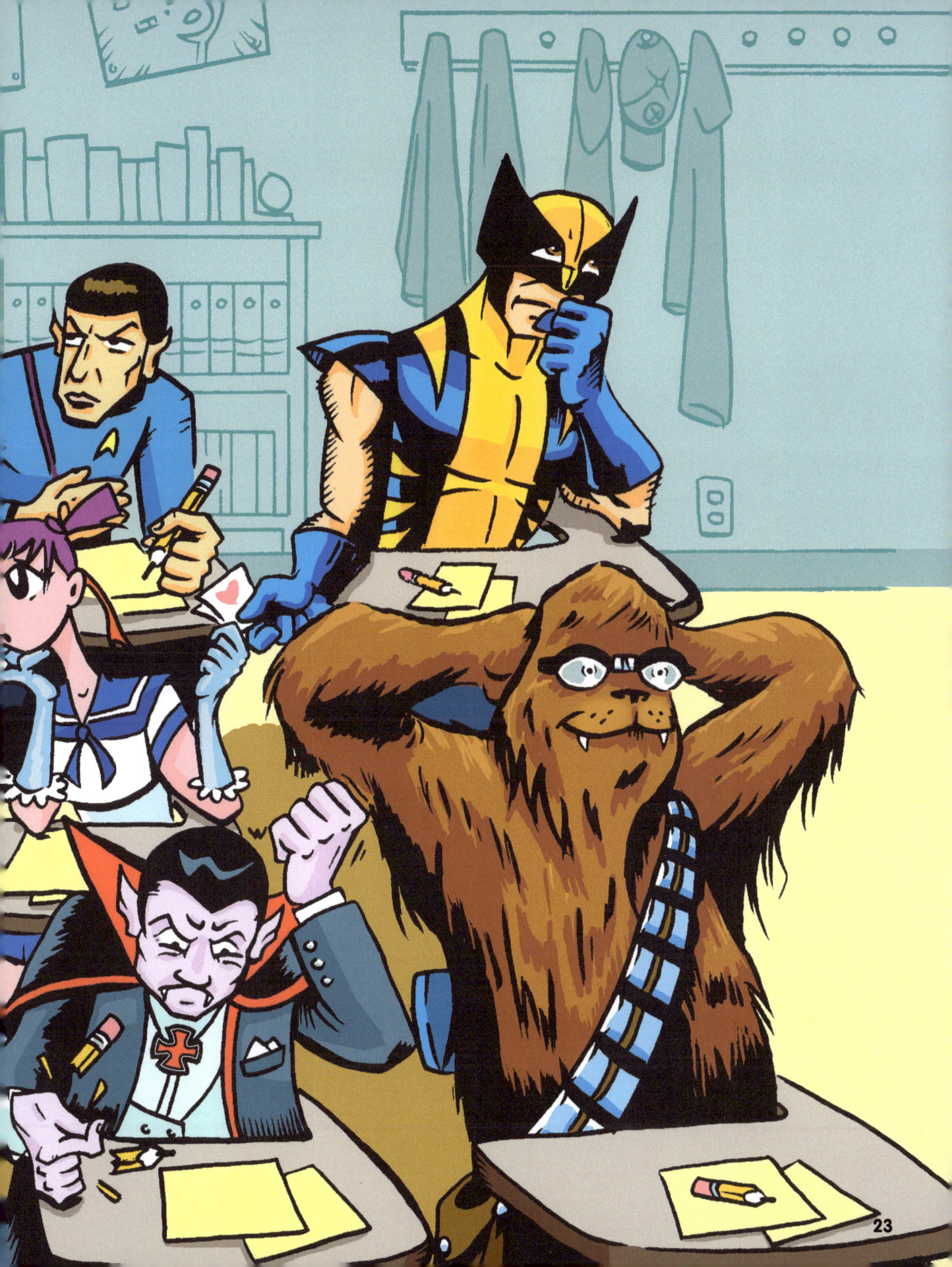

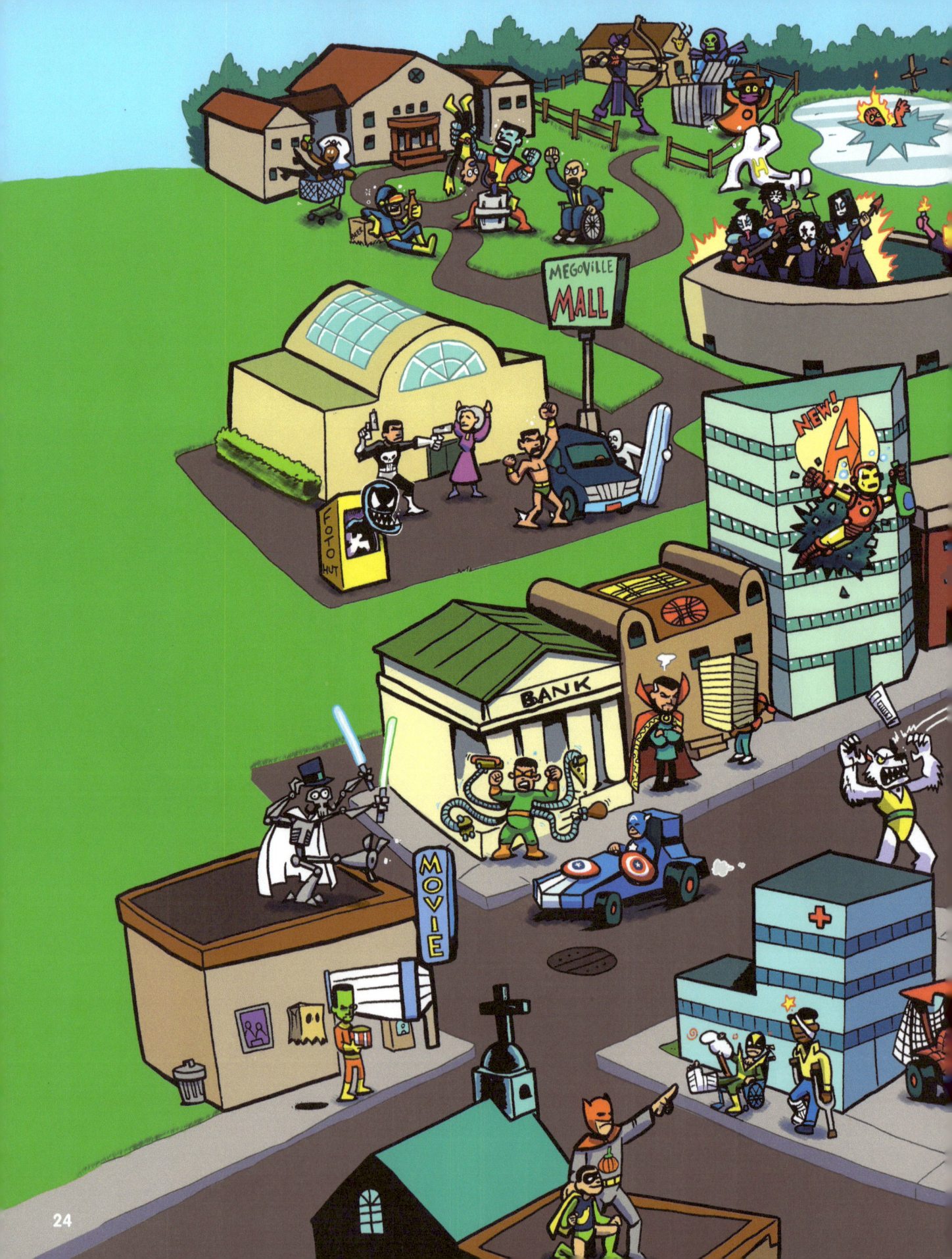

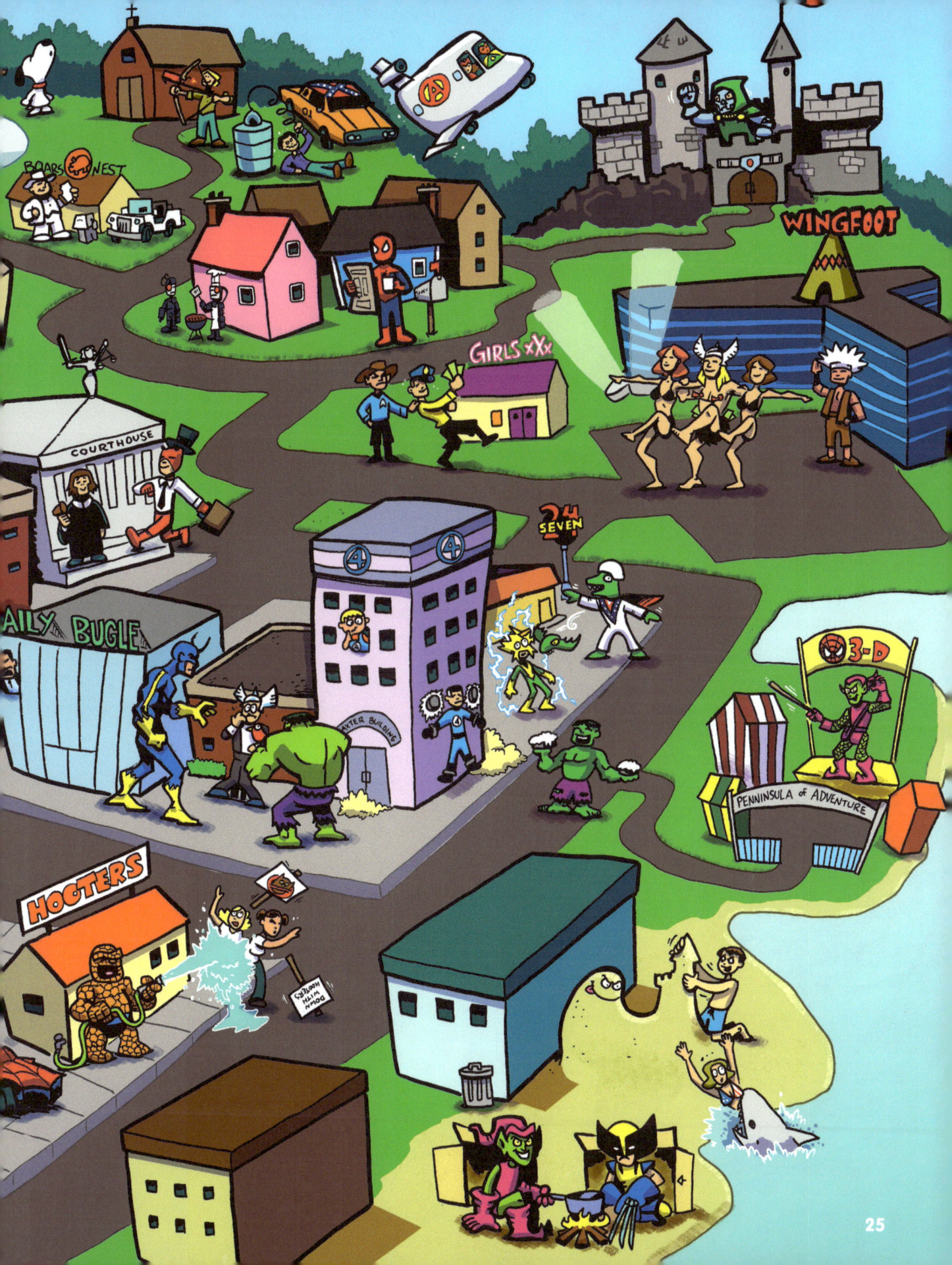

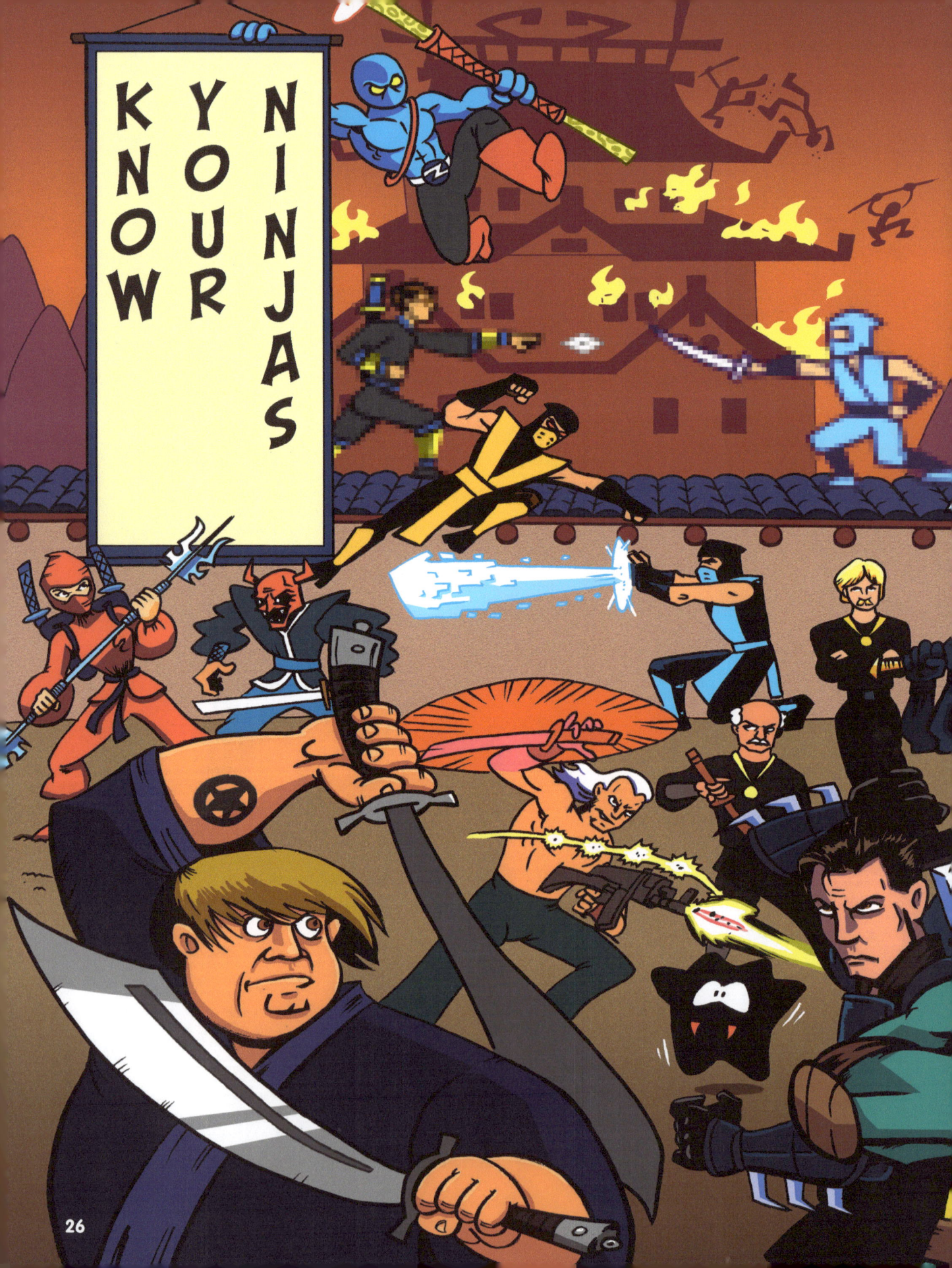

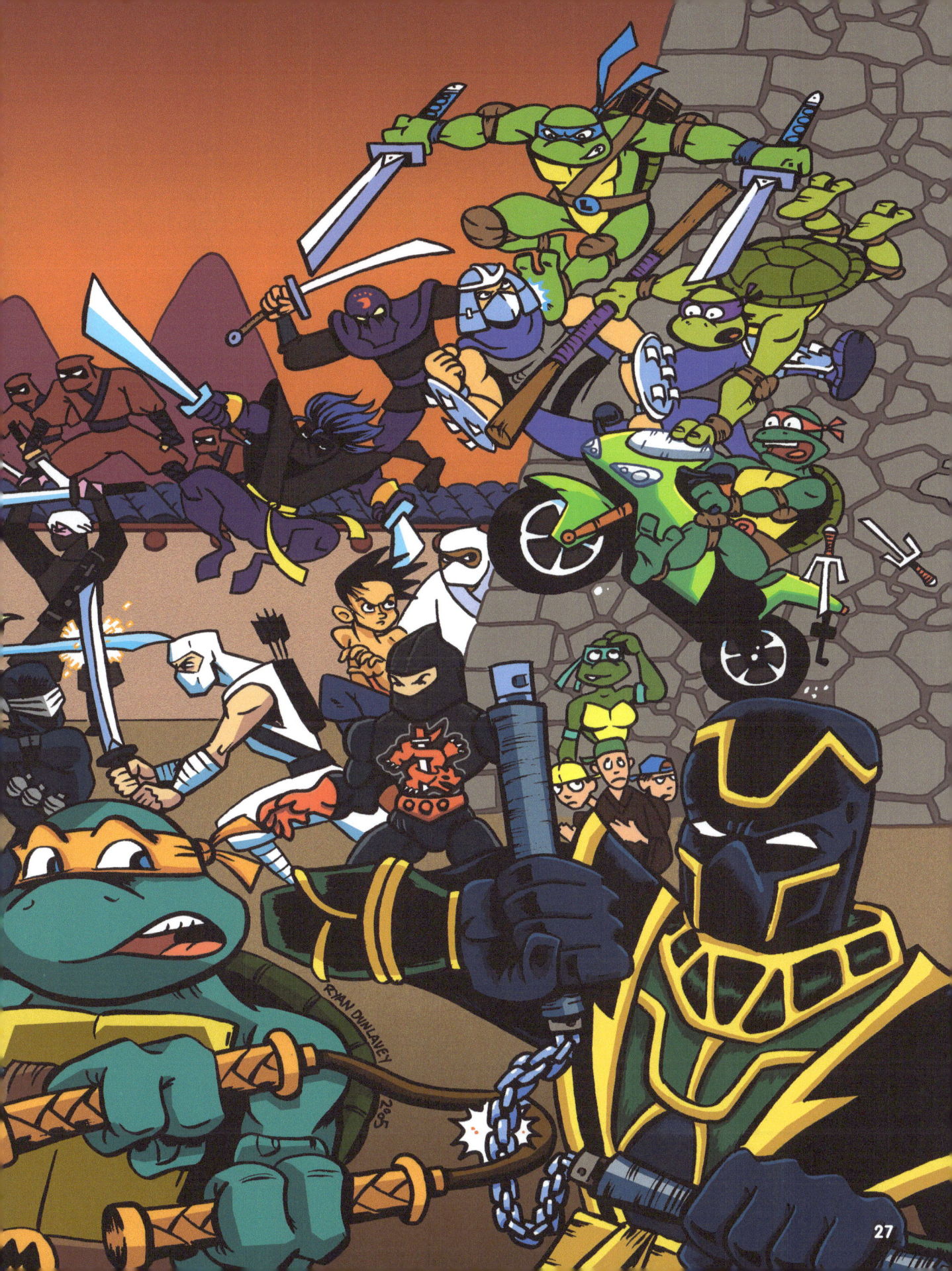

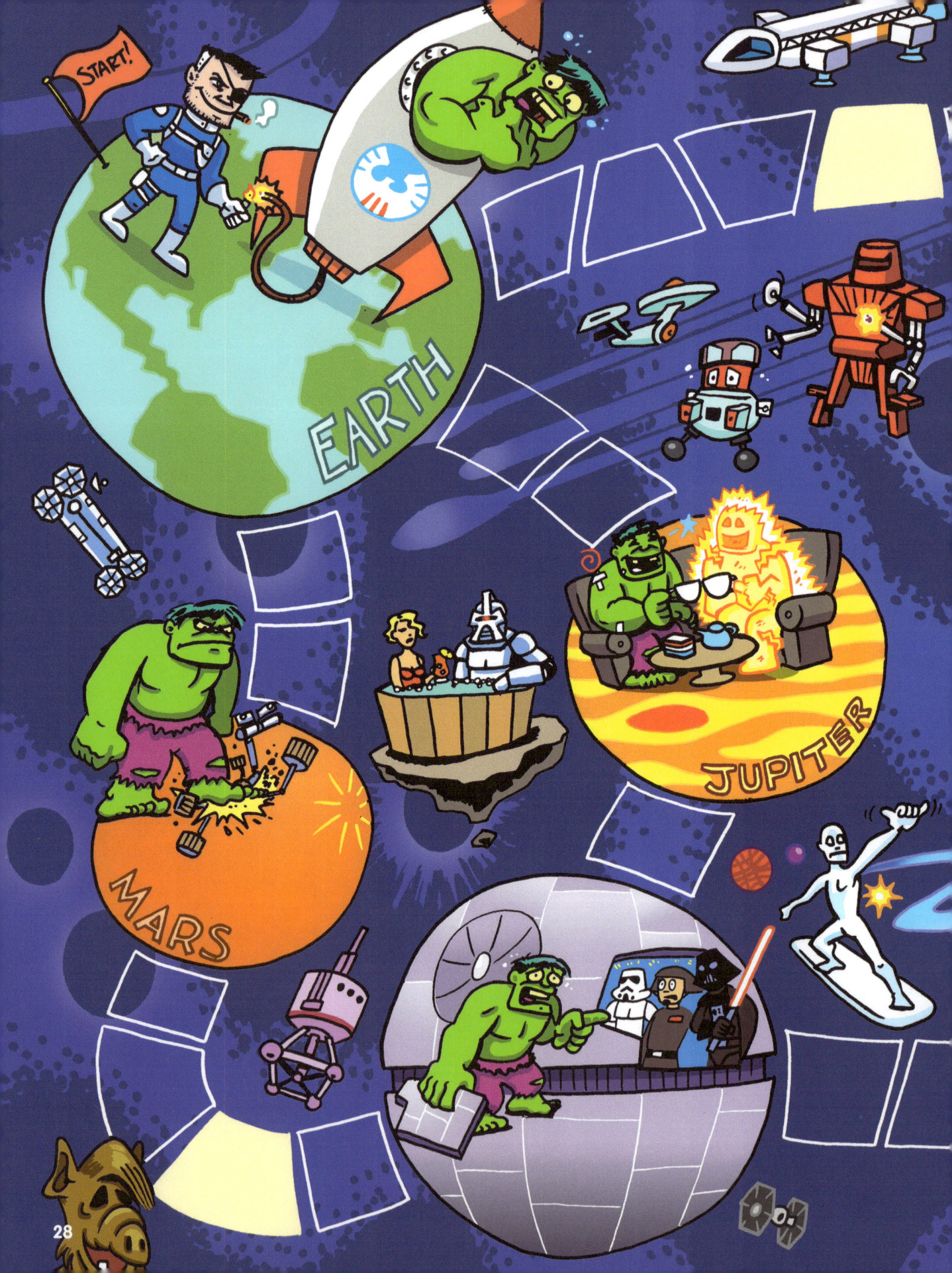

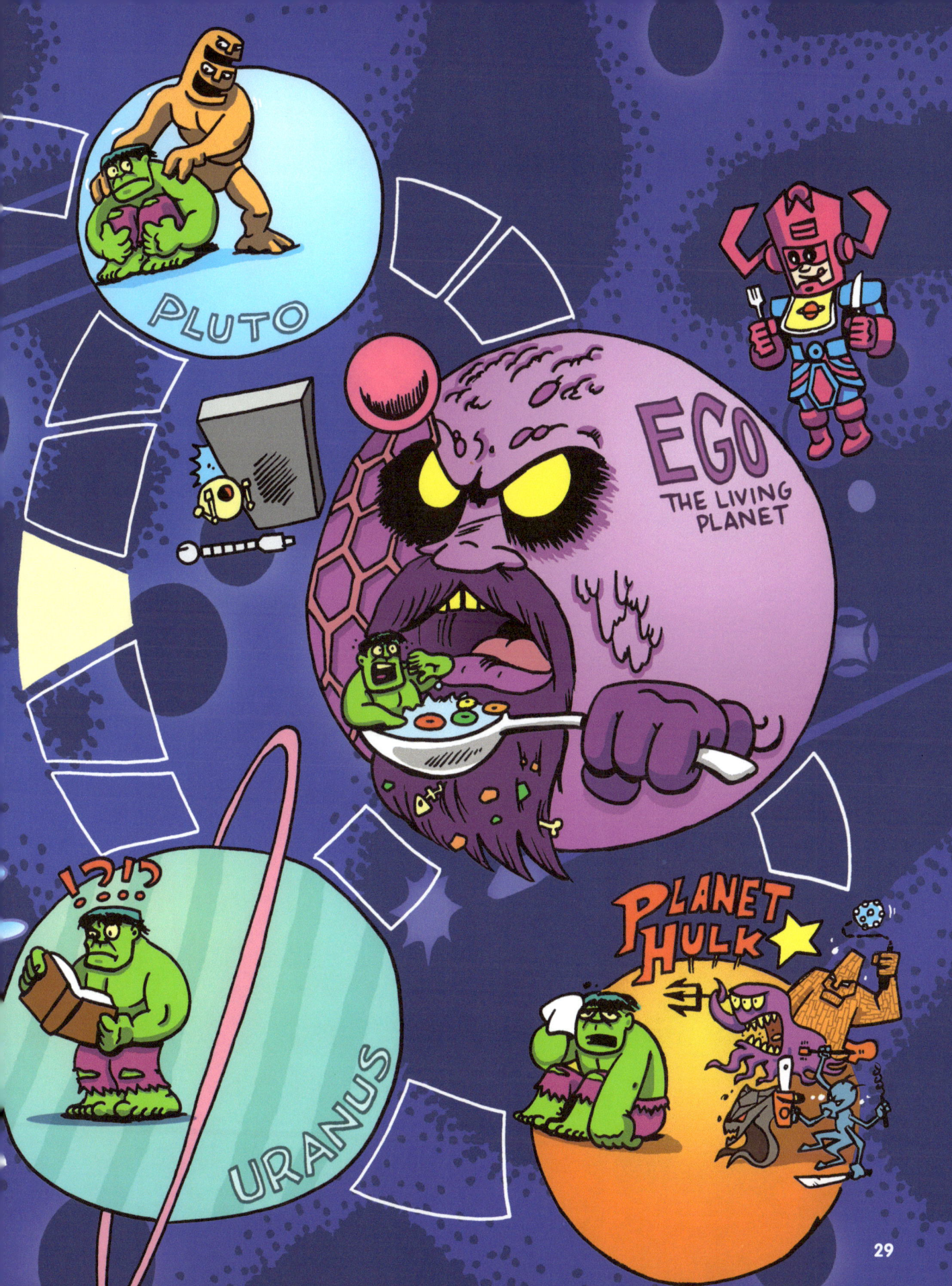

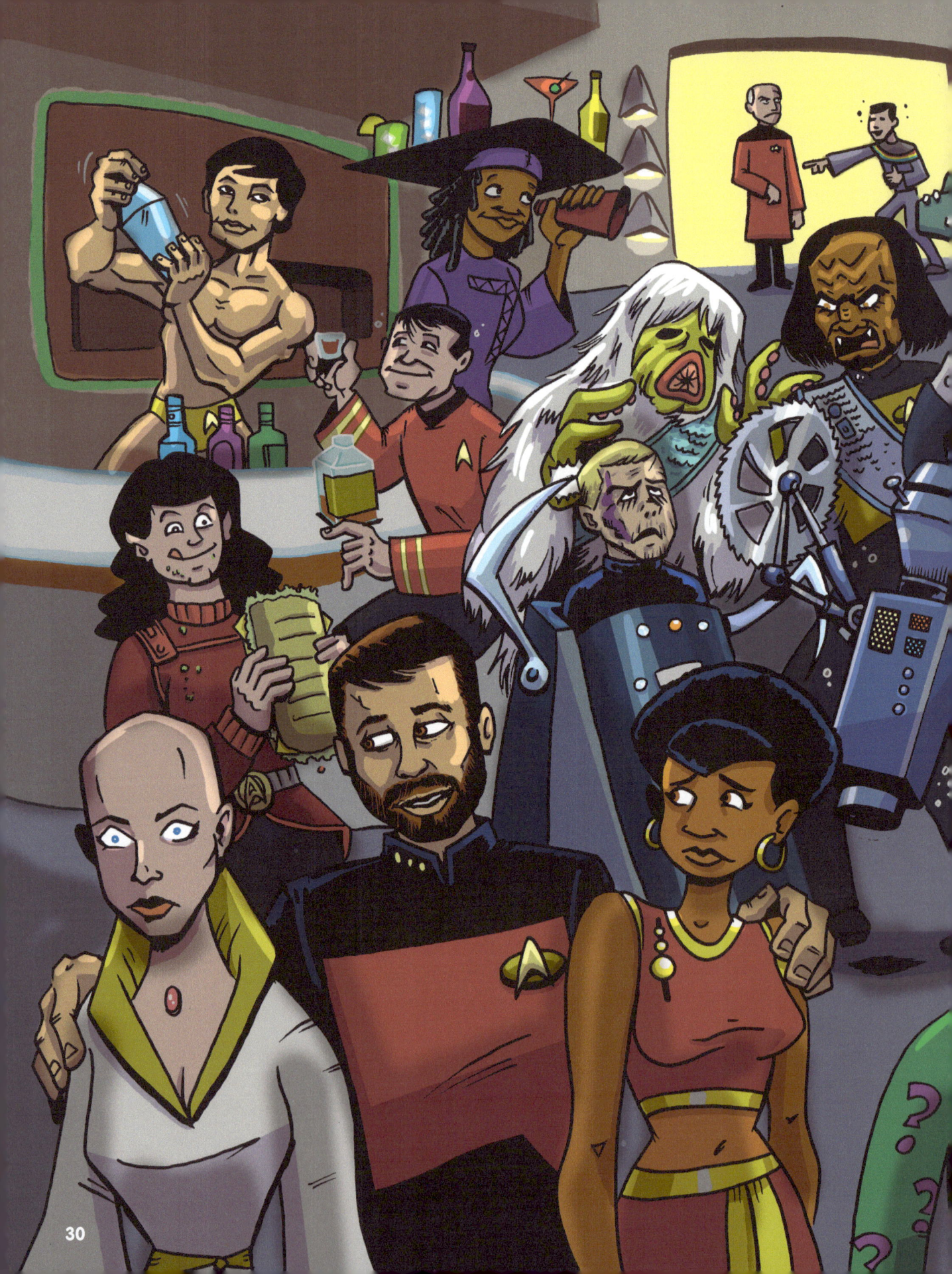

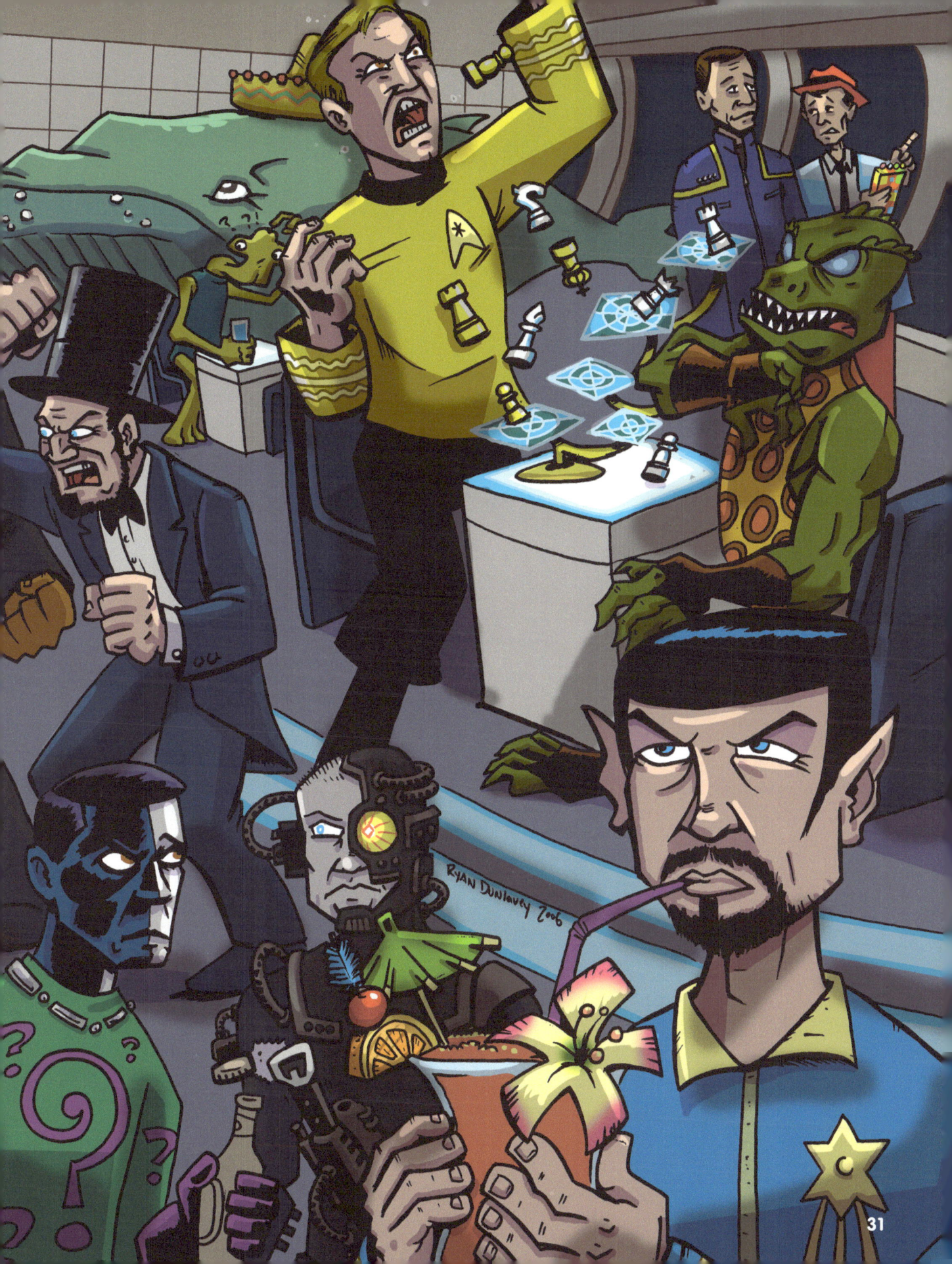

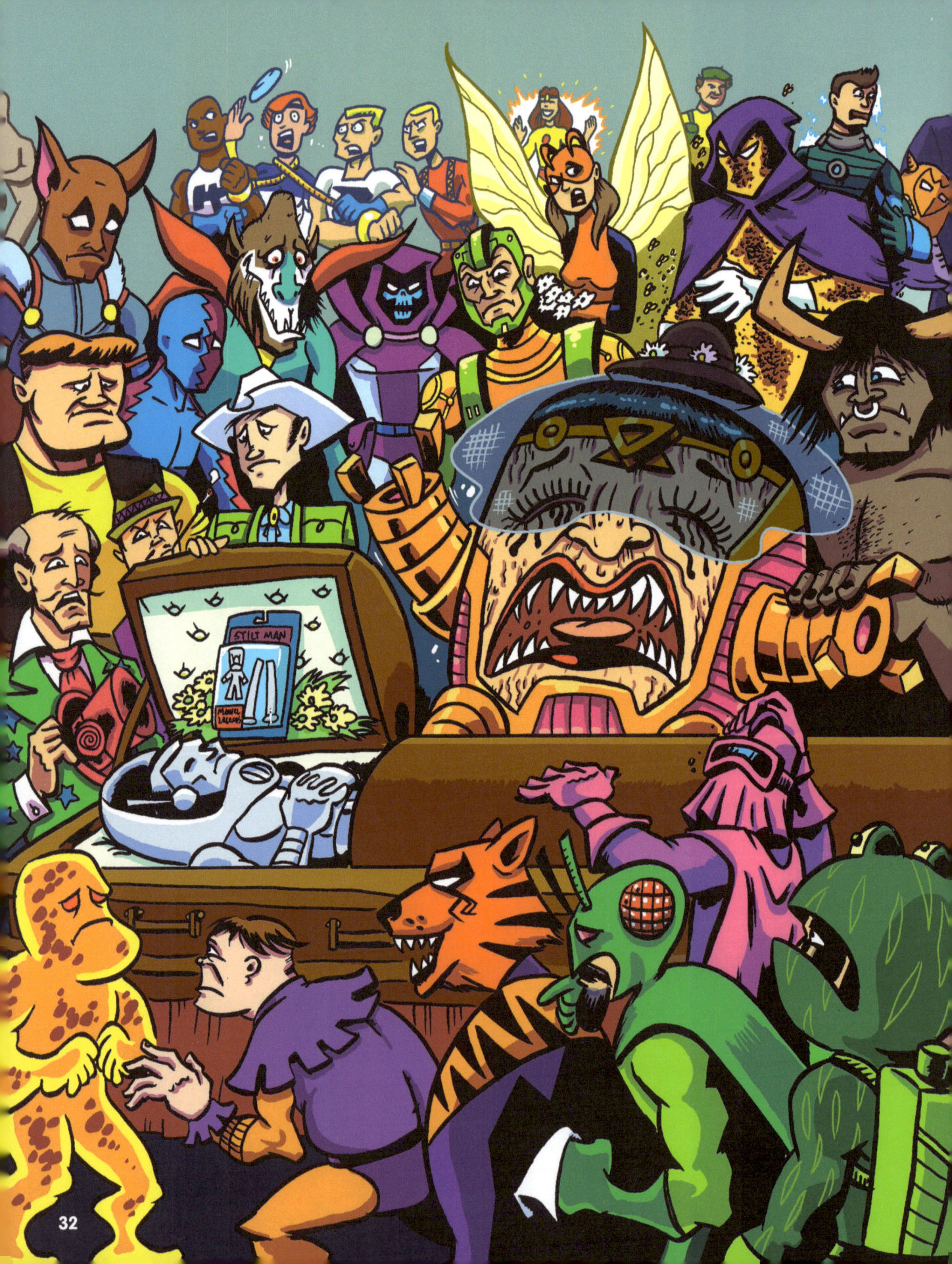

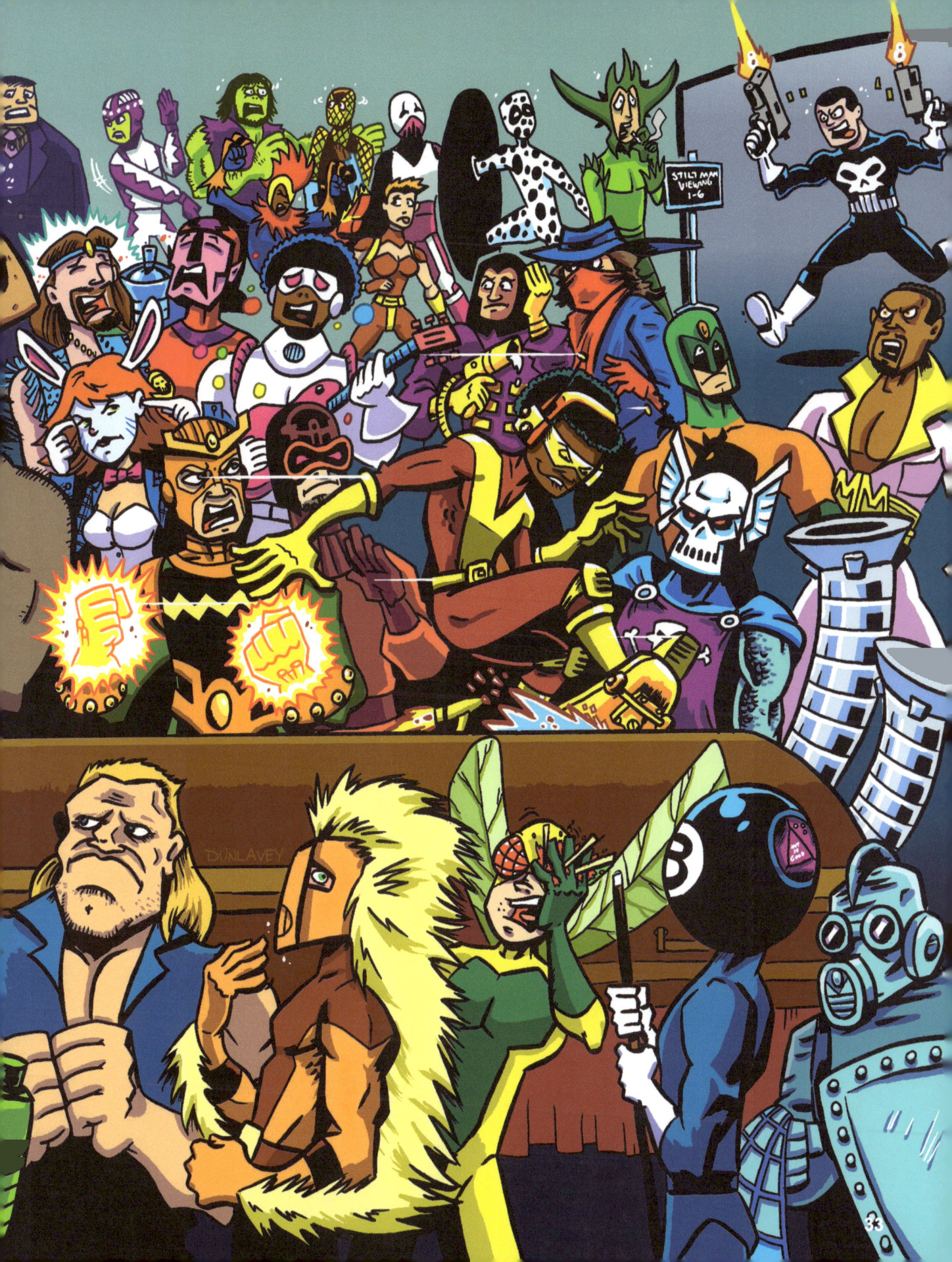

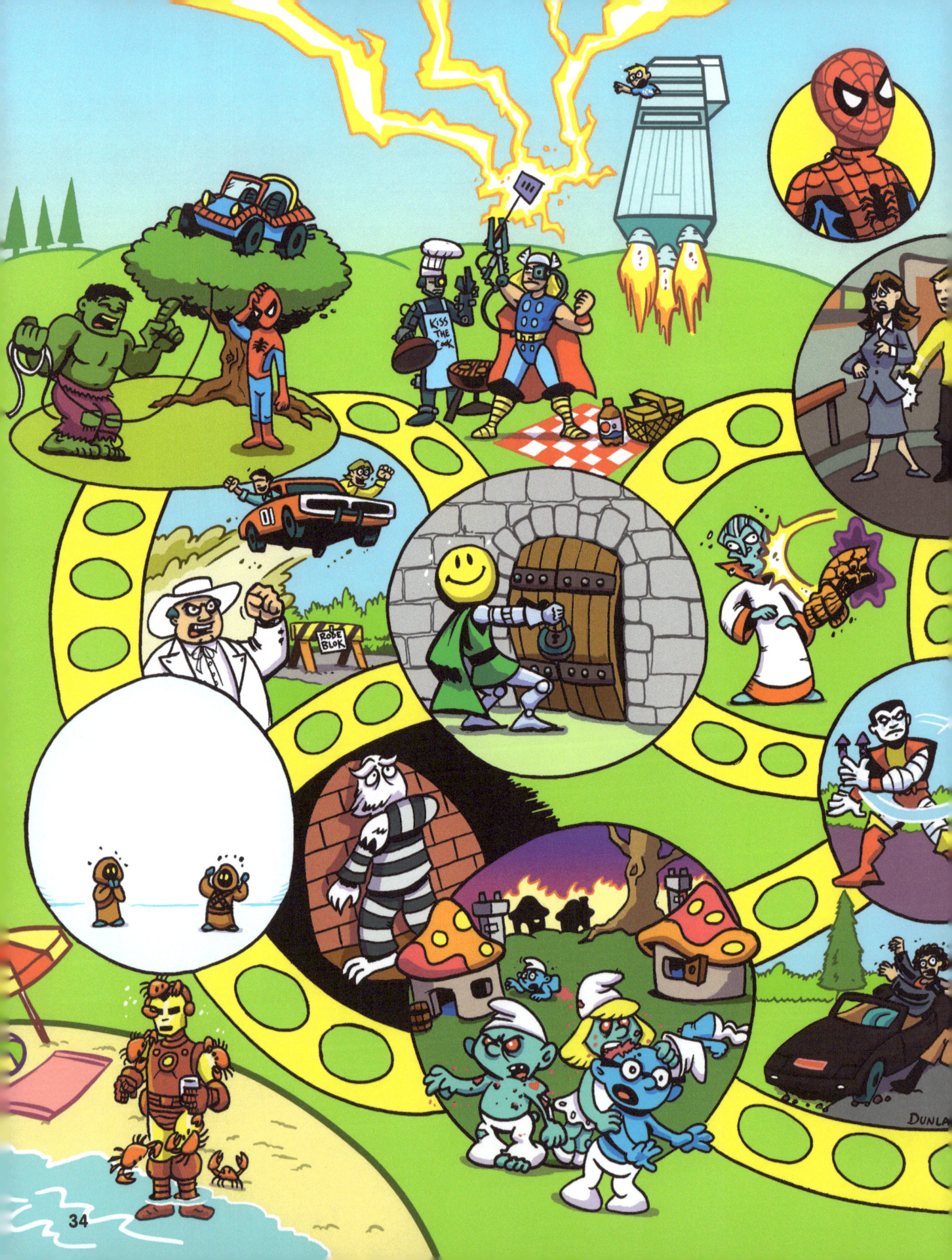

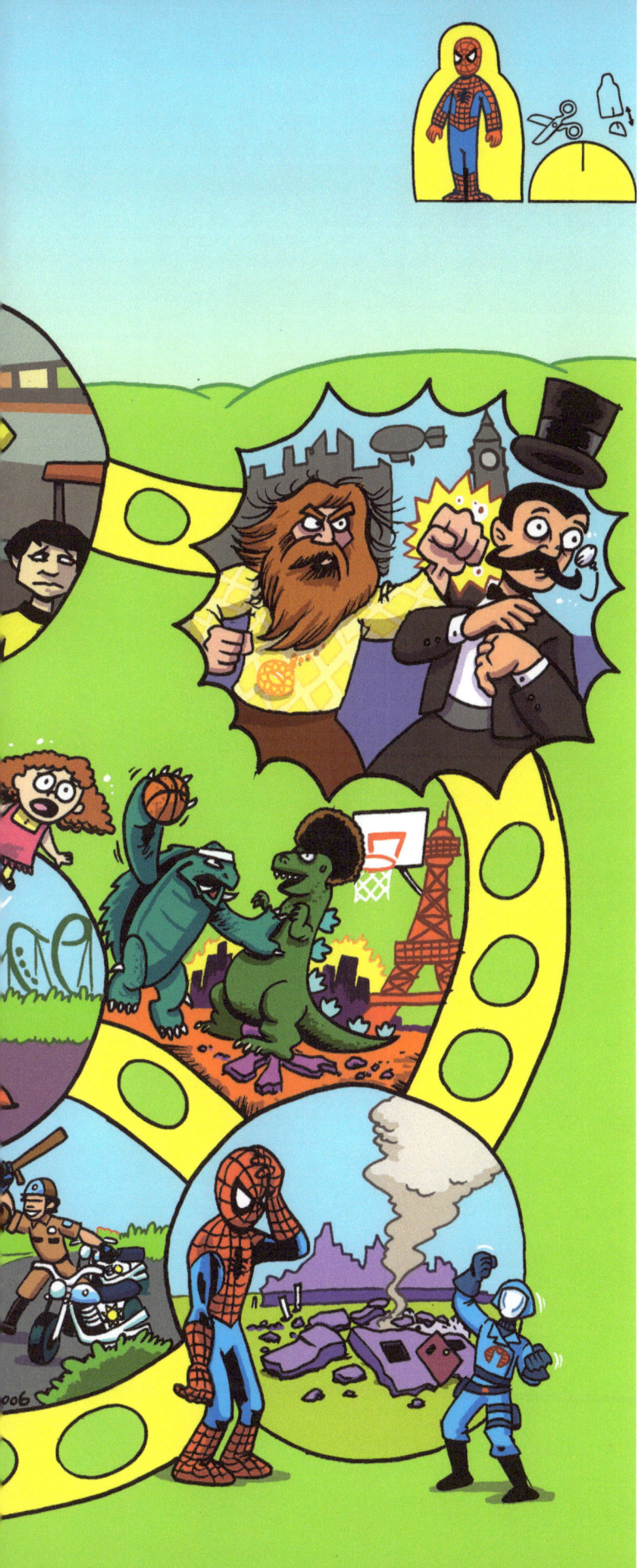

Fans

I sell prints of these one-of-every-character illustrations at comic conventions. They're colorful and fun and make a great display that draws people over, usually resulting in a sale of a print or as a gateway to introducing them to one of my own comics or just a friendly smile or compliment from a stranger, which is always nice.

But then there's the people who just stare and stare and stare at these drawings while they call out the names of Every. Single. Character.

When a kid does it, it's just annoying, but when a teenager or adult does it's unbearable.

Worst of all, none of them ever actually buy anything or interact with me in any way whatsoever, and they block me from engaging anyone else the whole time they're there.

Now I've made a whole book of this stuff.

I'm an idiot.

Ryan Dunlavey
April 2012

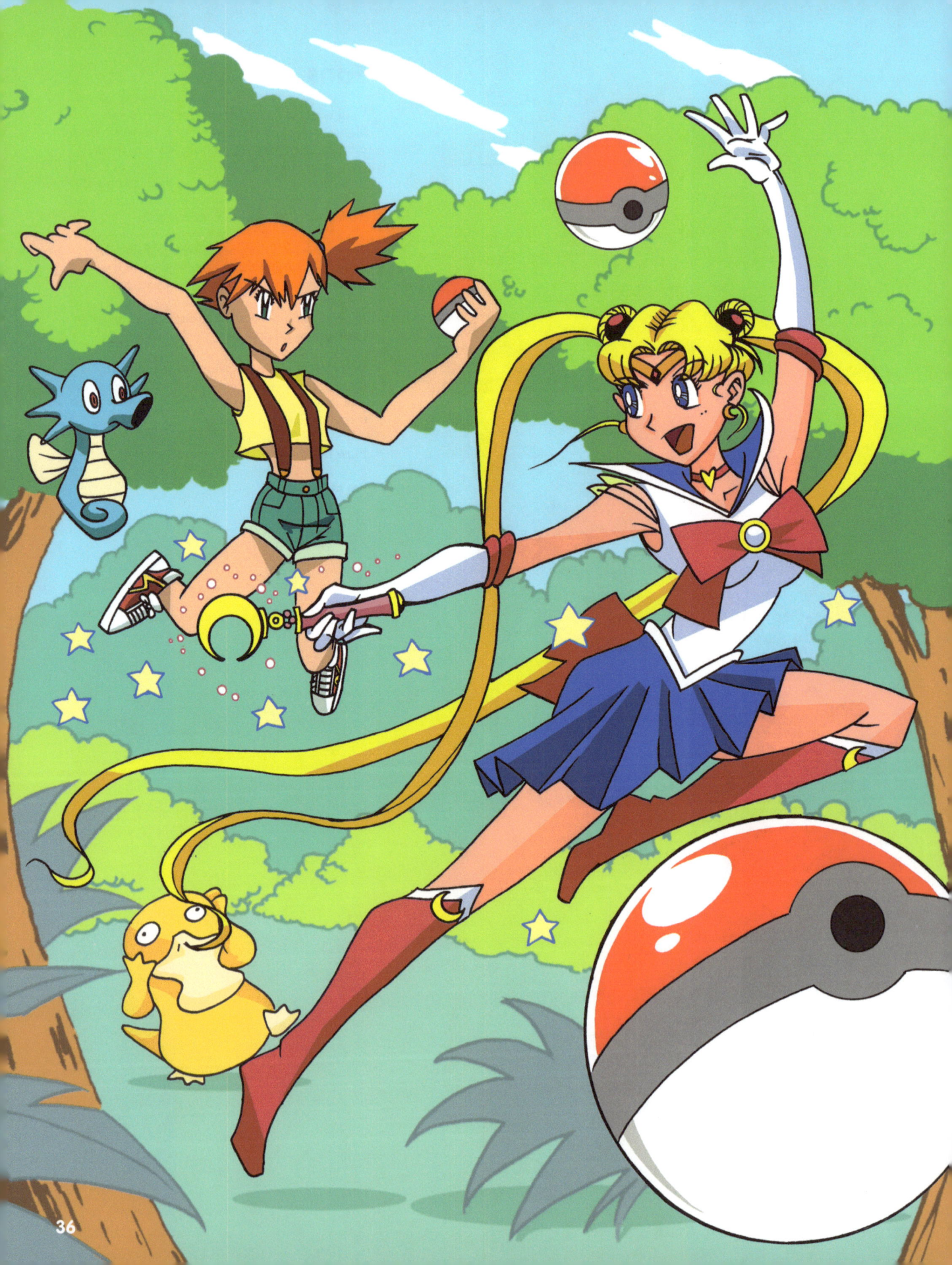

SUPER SUNDAY FUNNIES

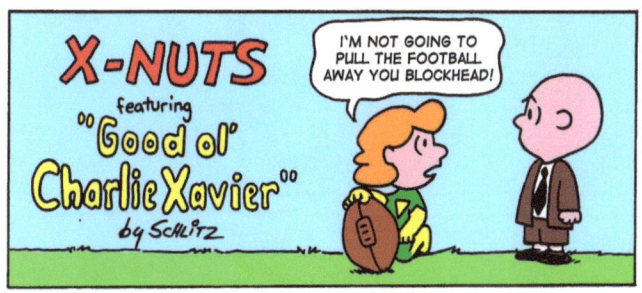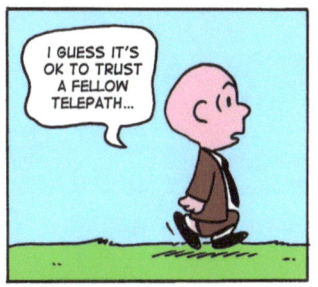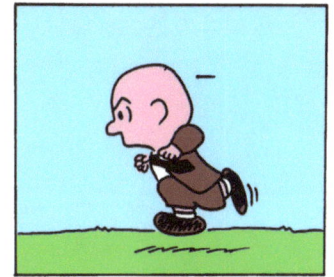
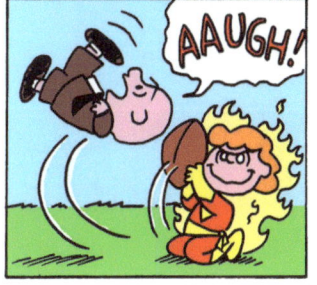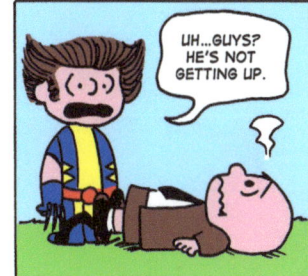

FANTASTIC FAMILY CIRCUS

PHANTOM THE MENACE

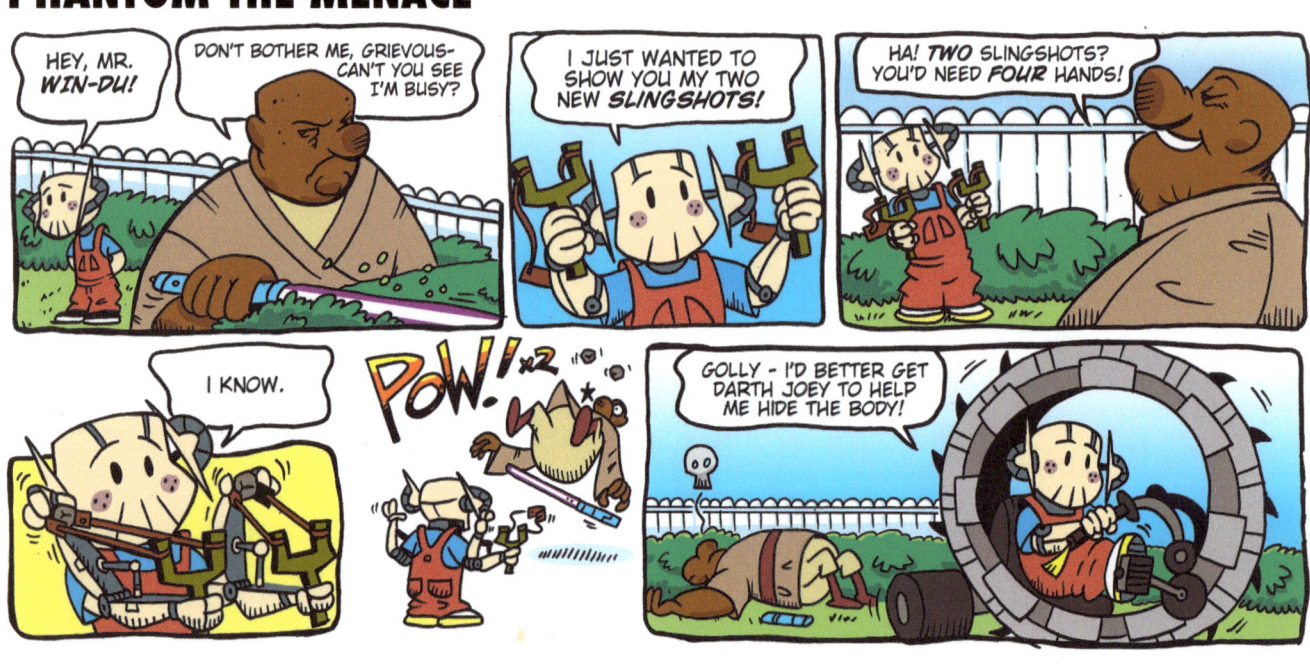

CRINGERFIELD

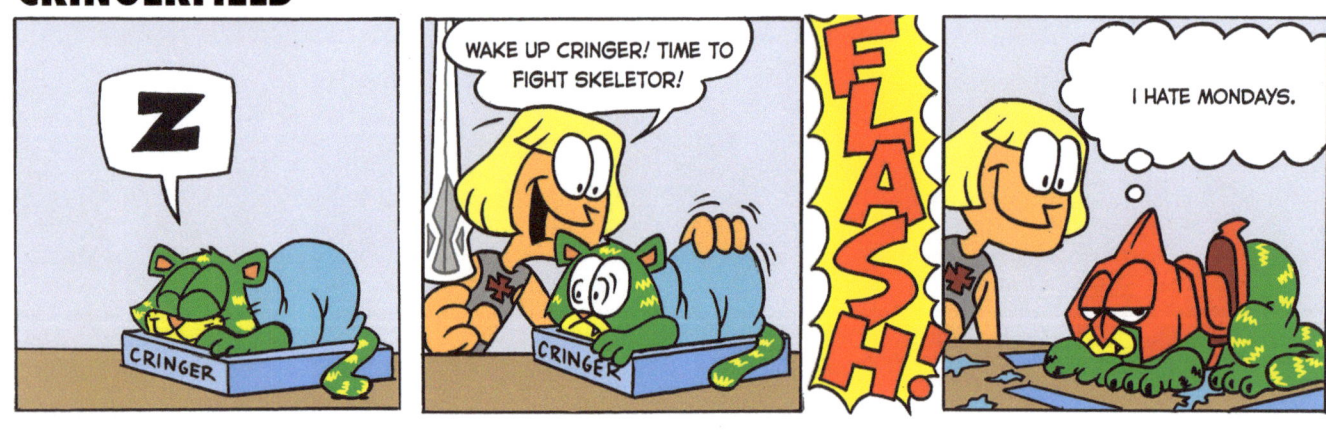

KRAVEN AND HOBBES

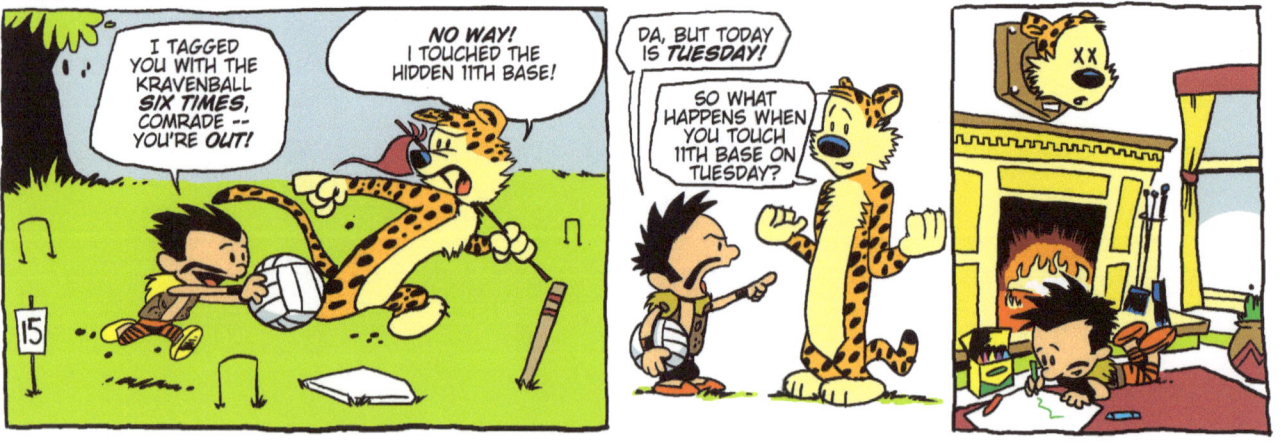

NANCY CALLAHAN
by Frank Bushmiller

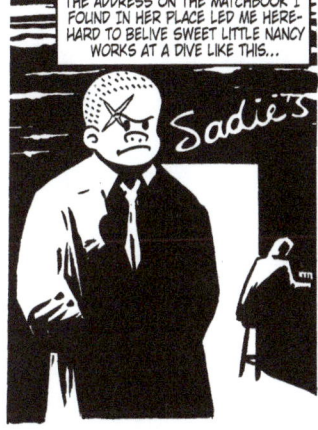
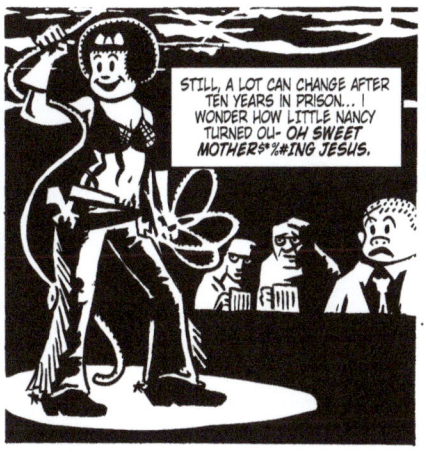

THUNDERKATZENJAMMER KIDS

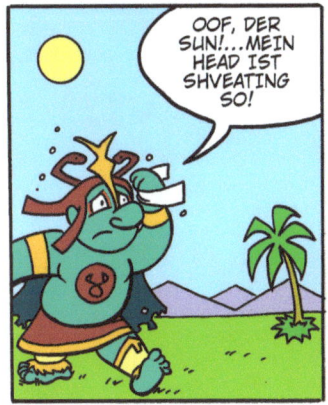
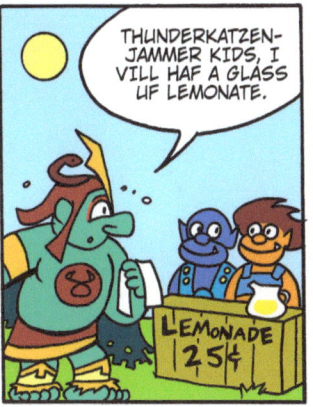
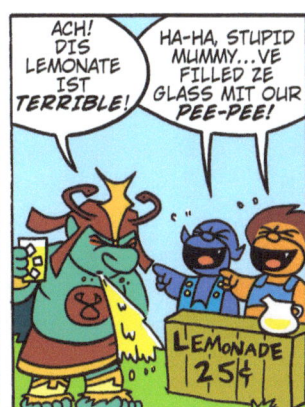

THE DARK SIDE

Ben knew there was no such thing as "The Force", he just liked seeing the whiny kid get zapped.

ORLANDO BLOOM COUNTY

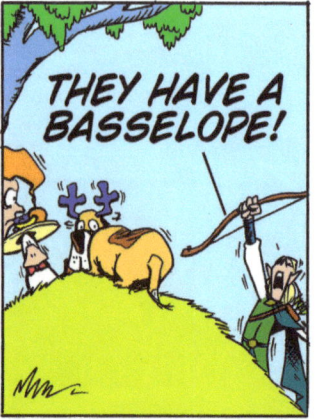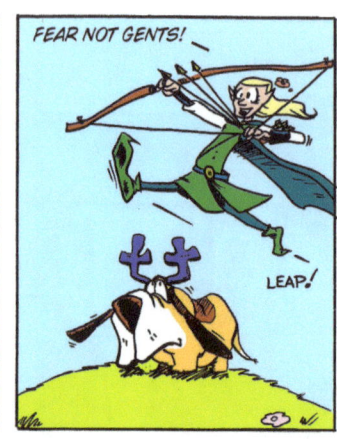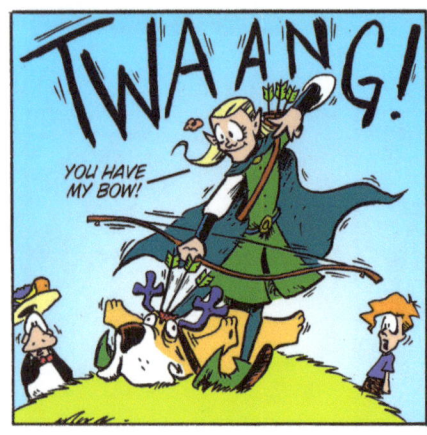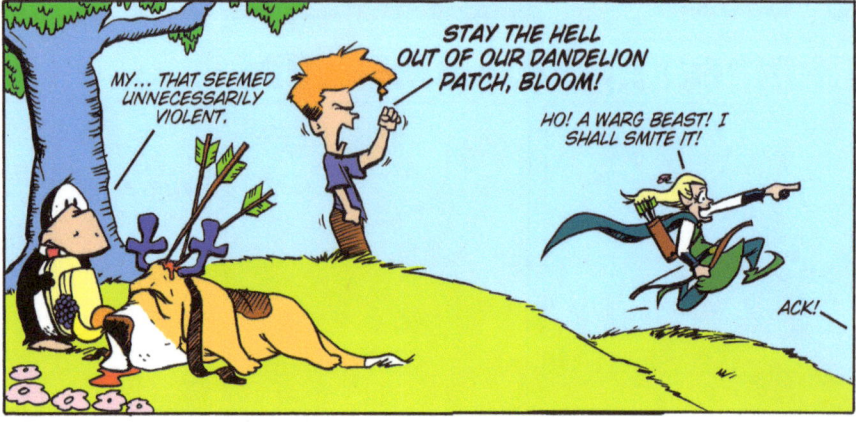

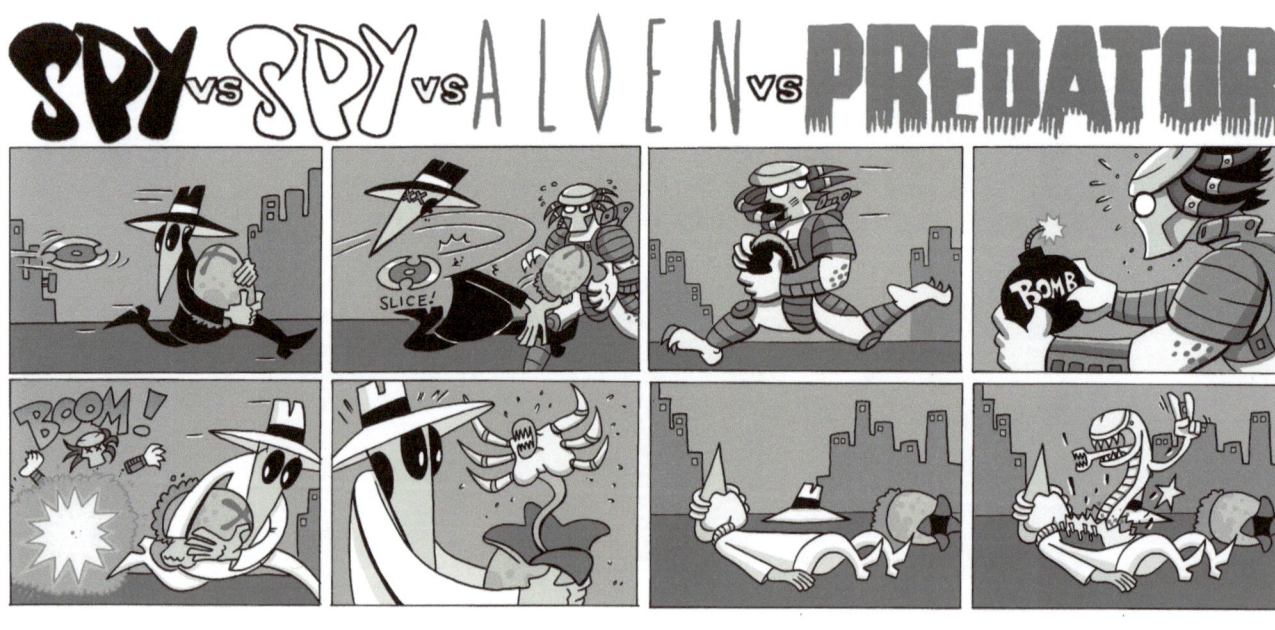

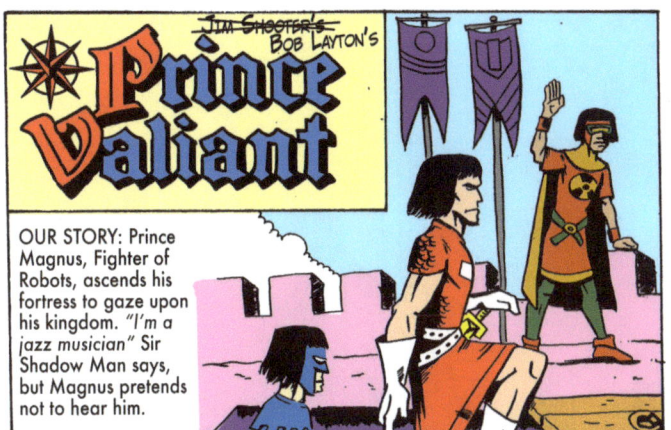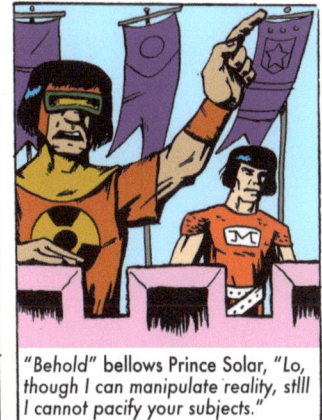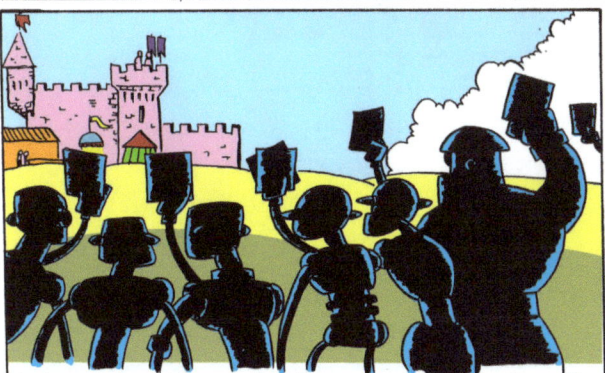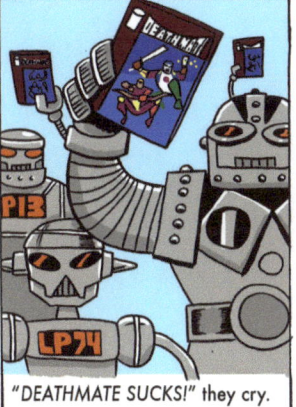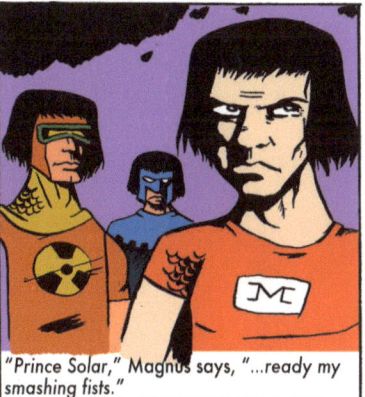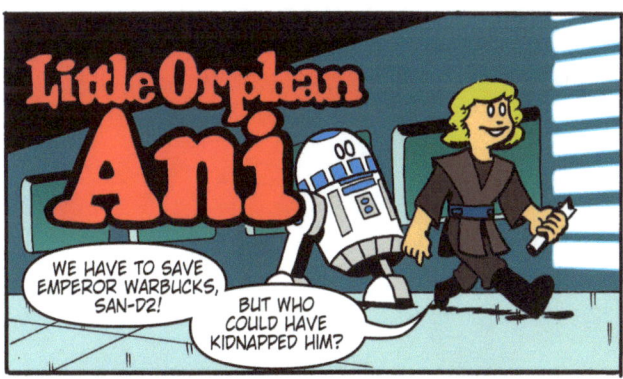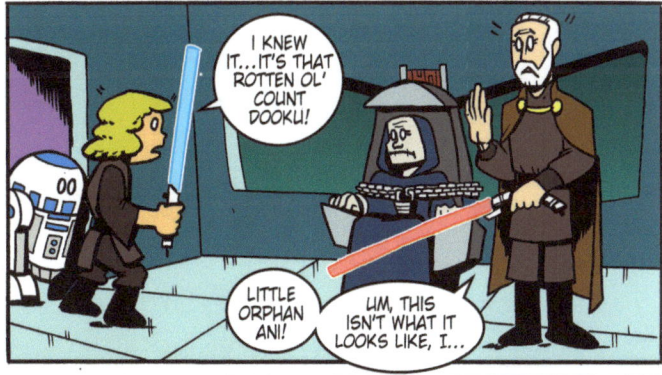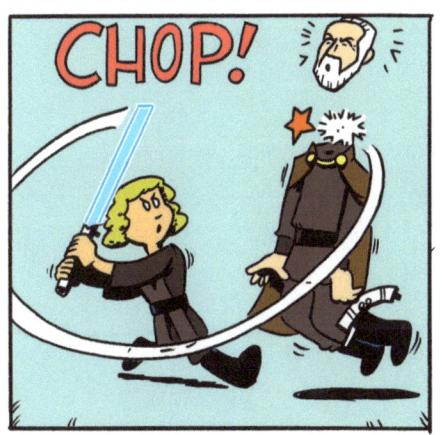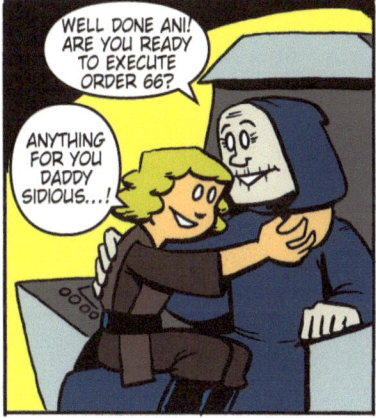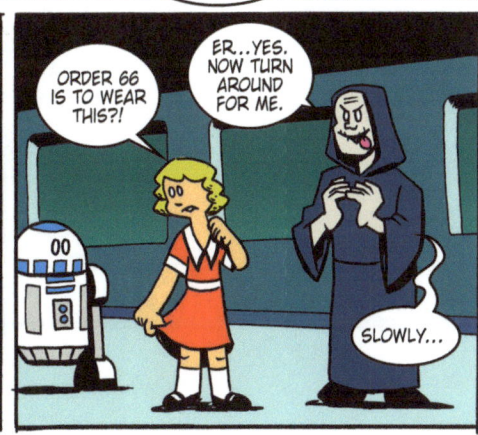

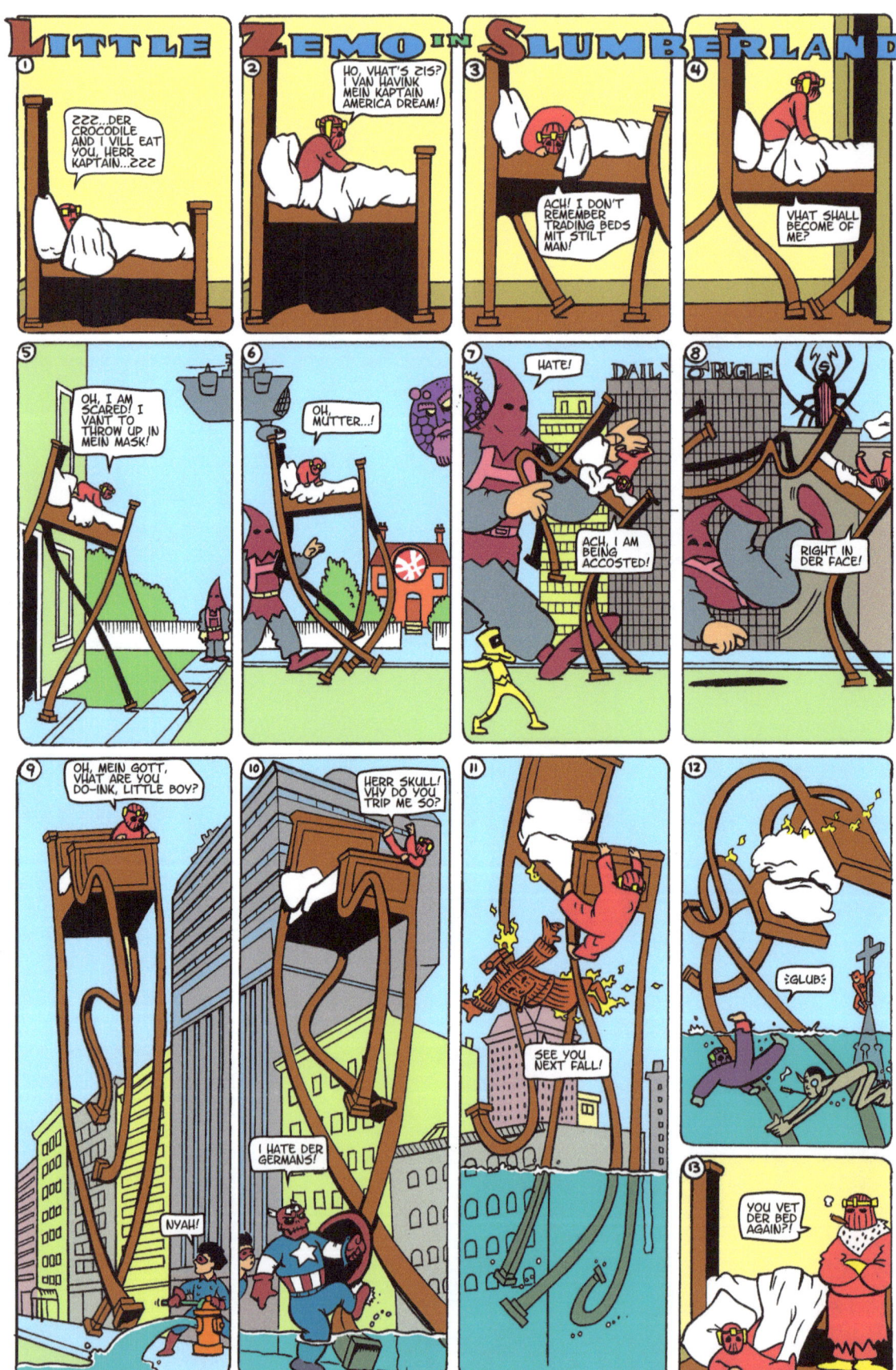

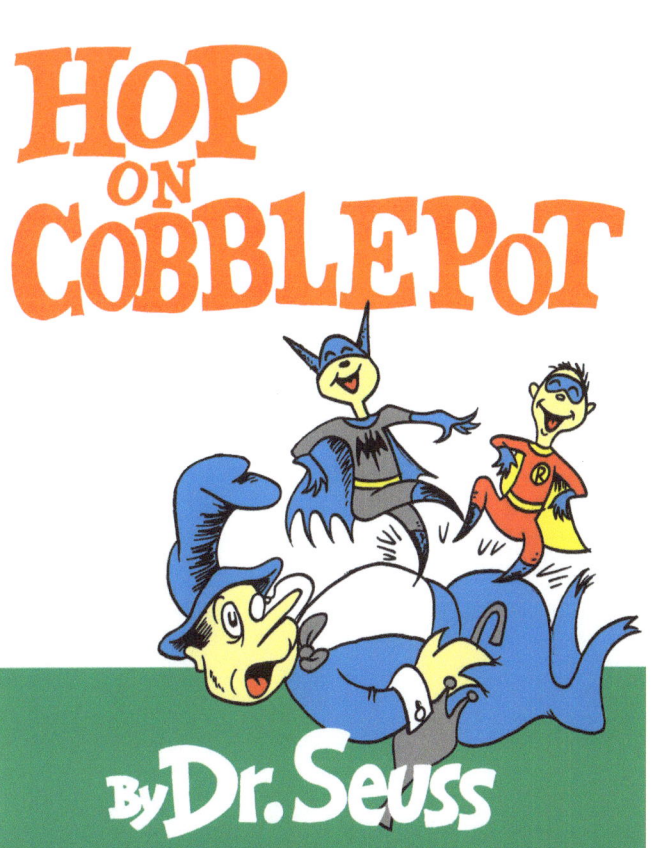
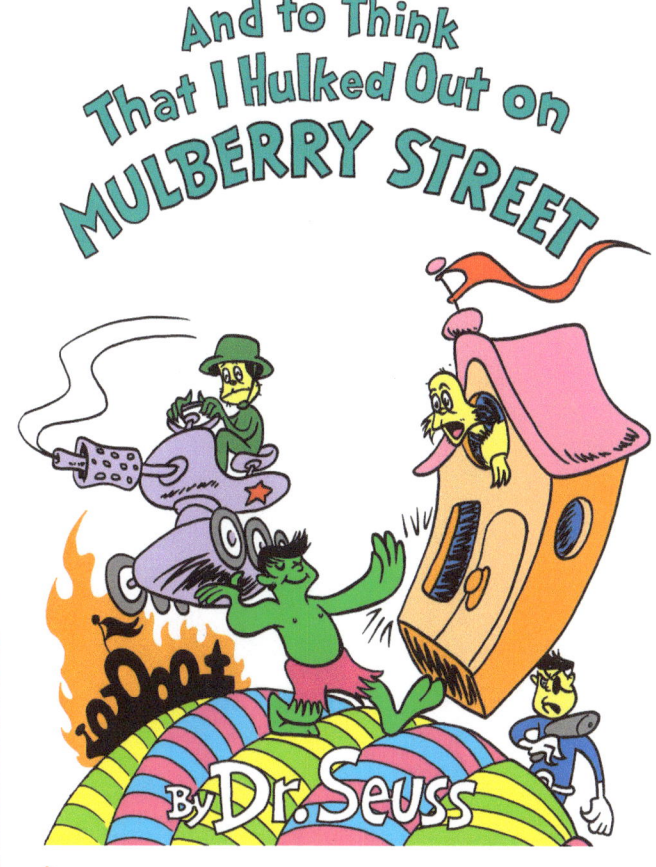
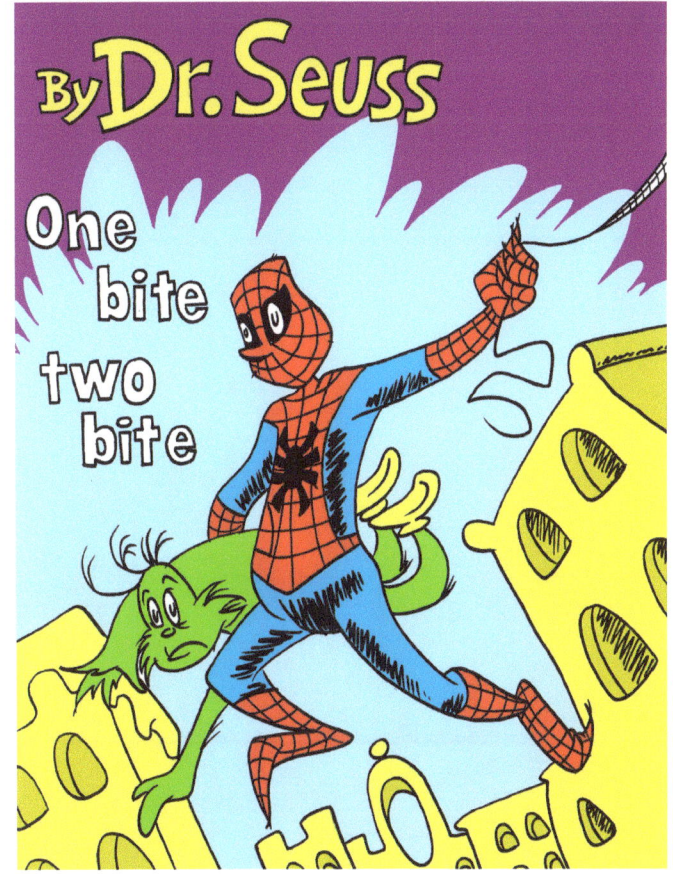
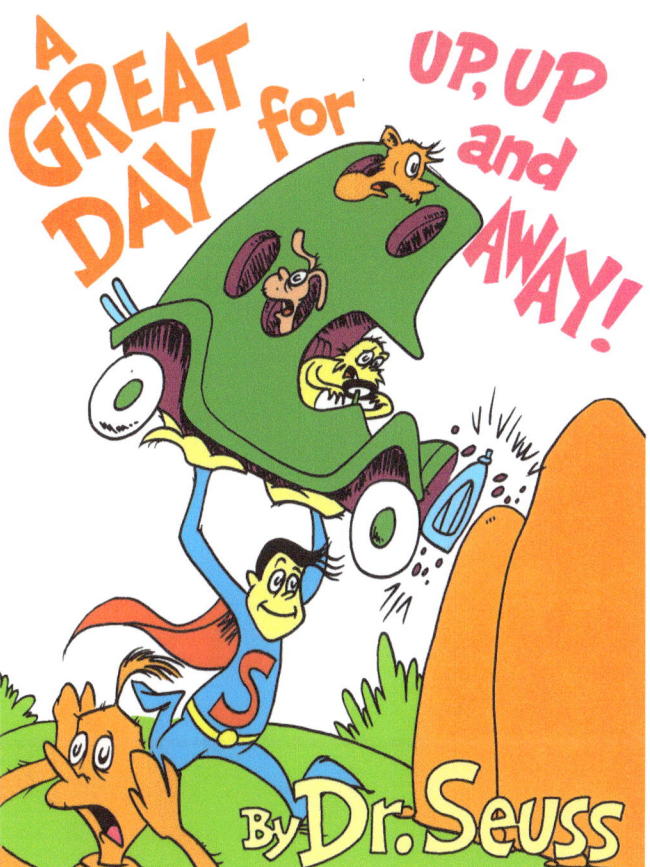

43

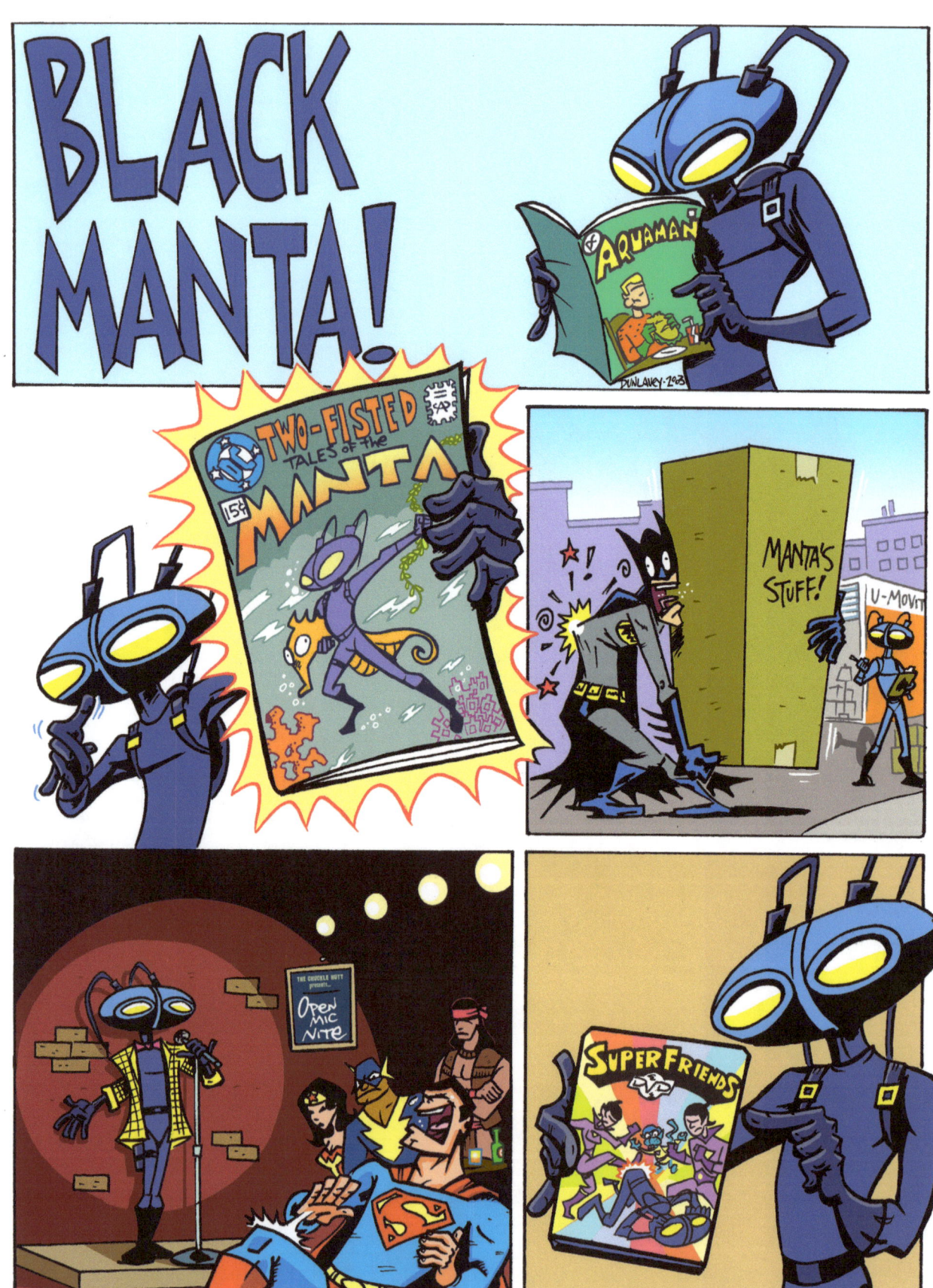

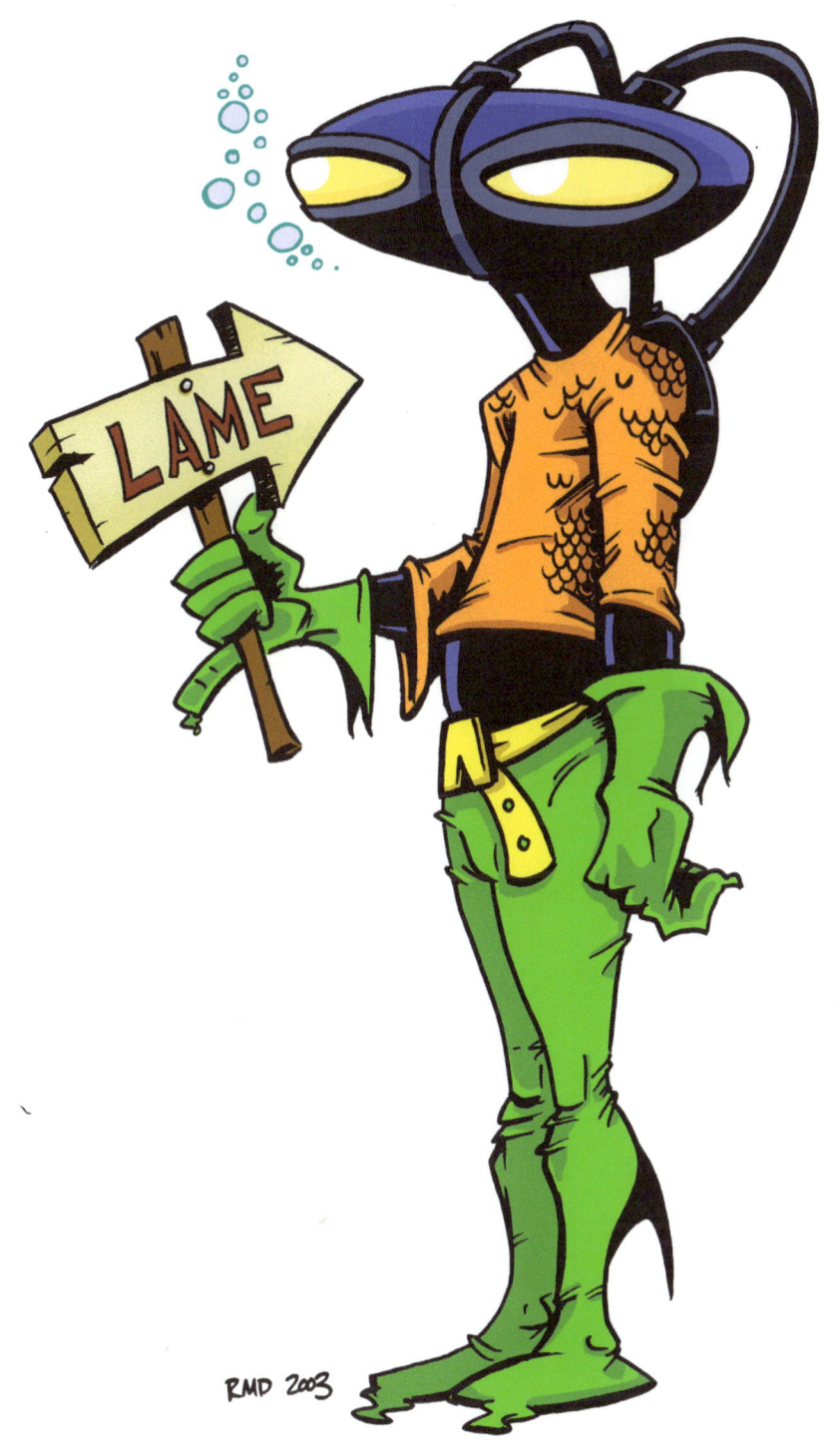

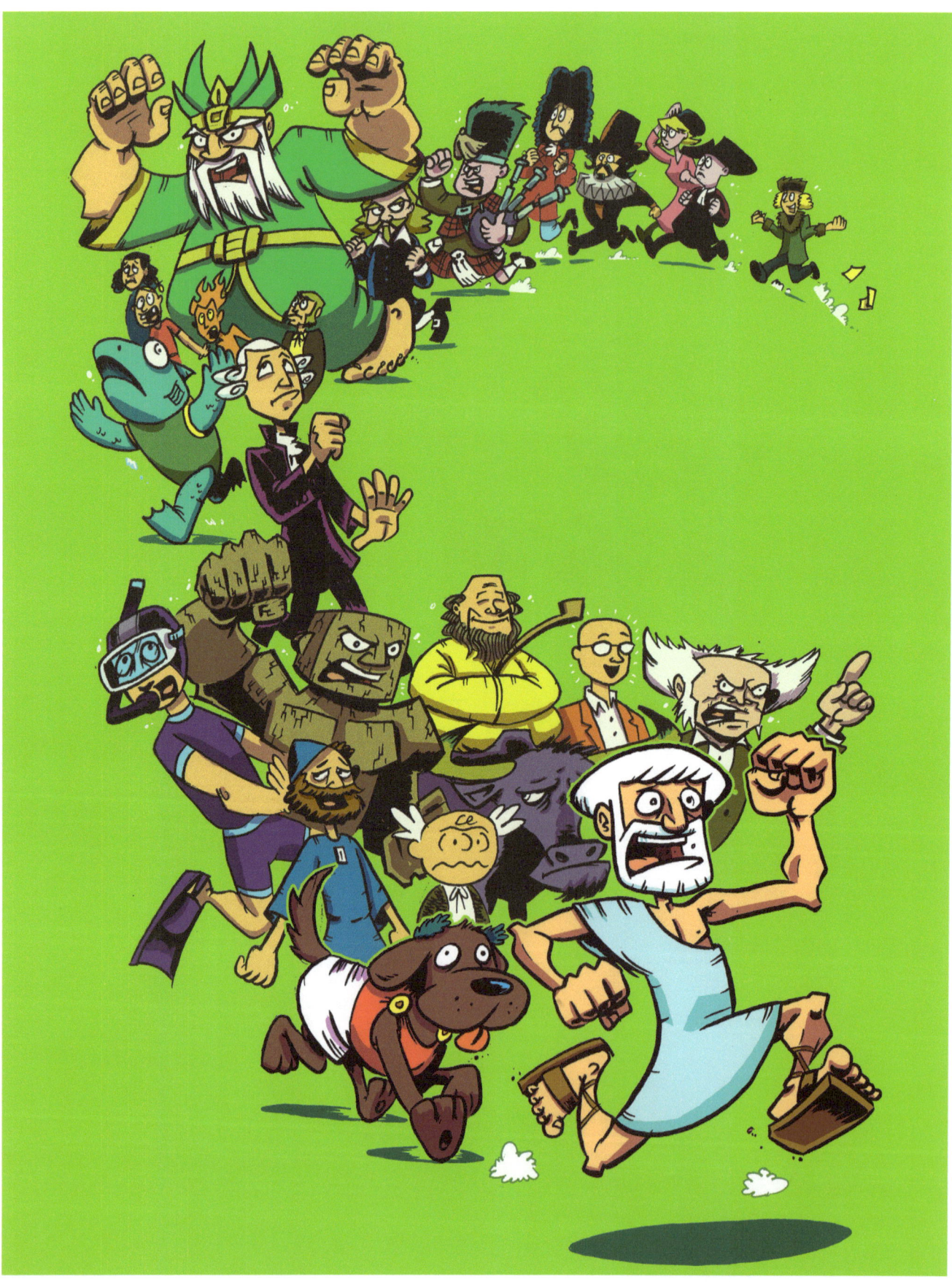

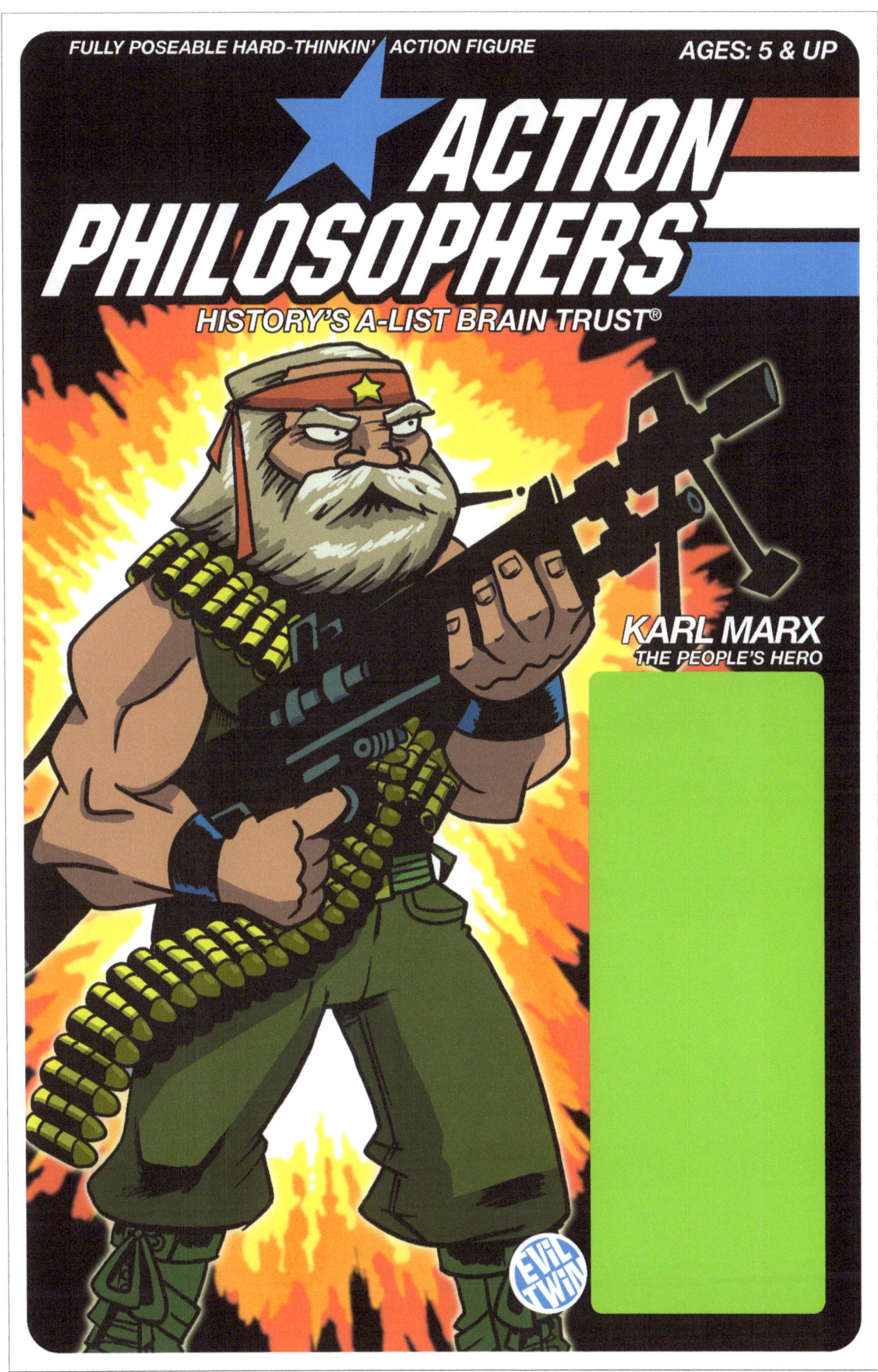

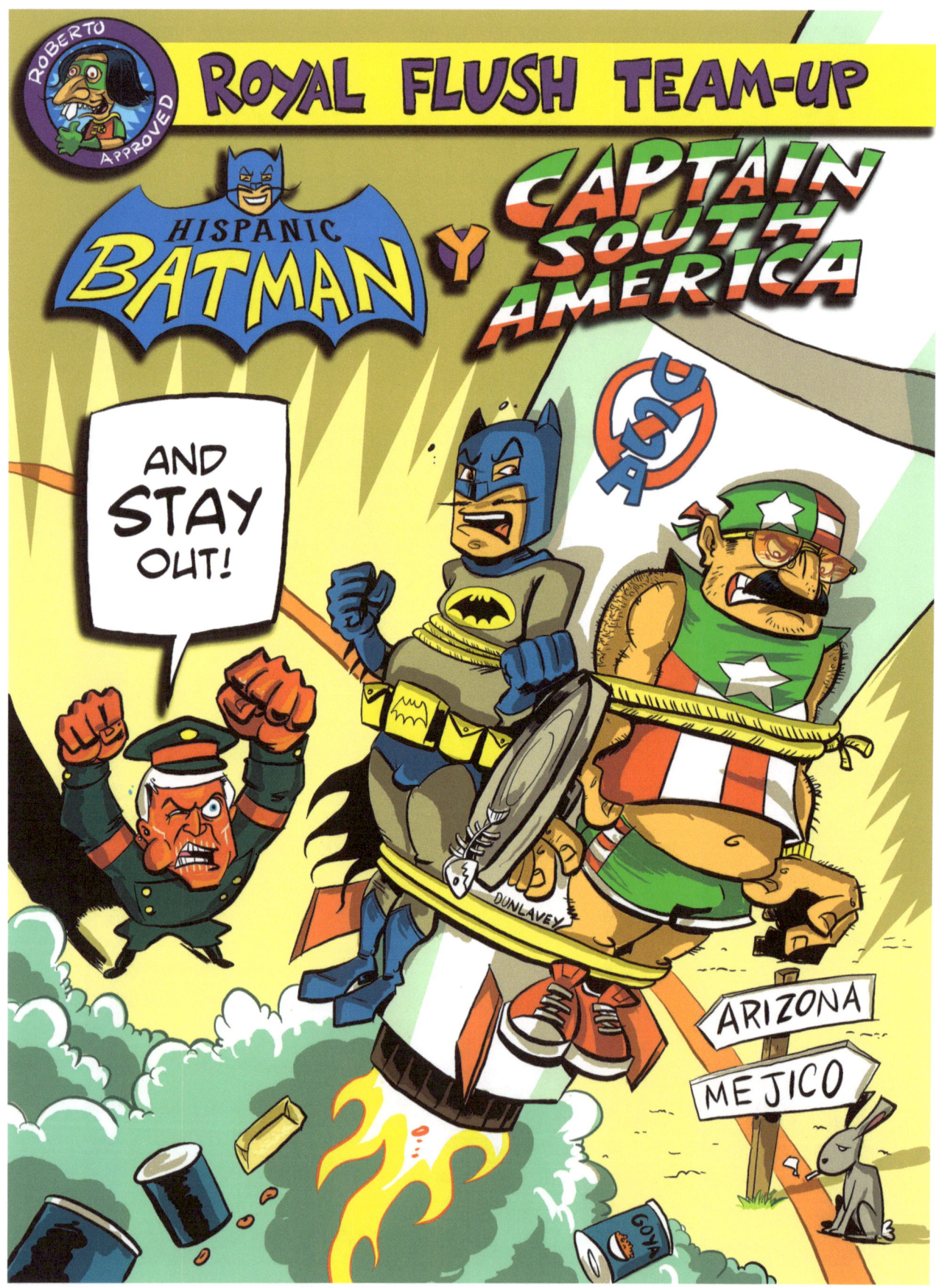

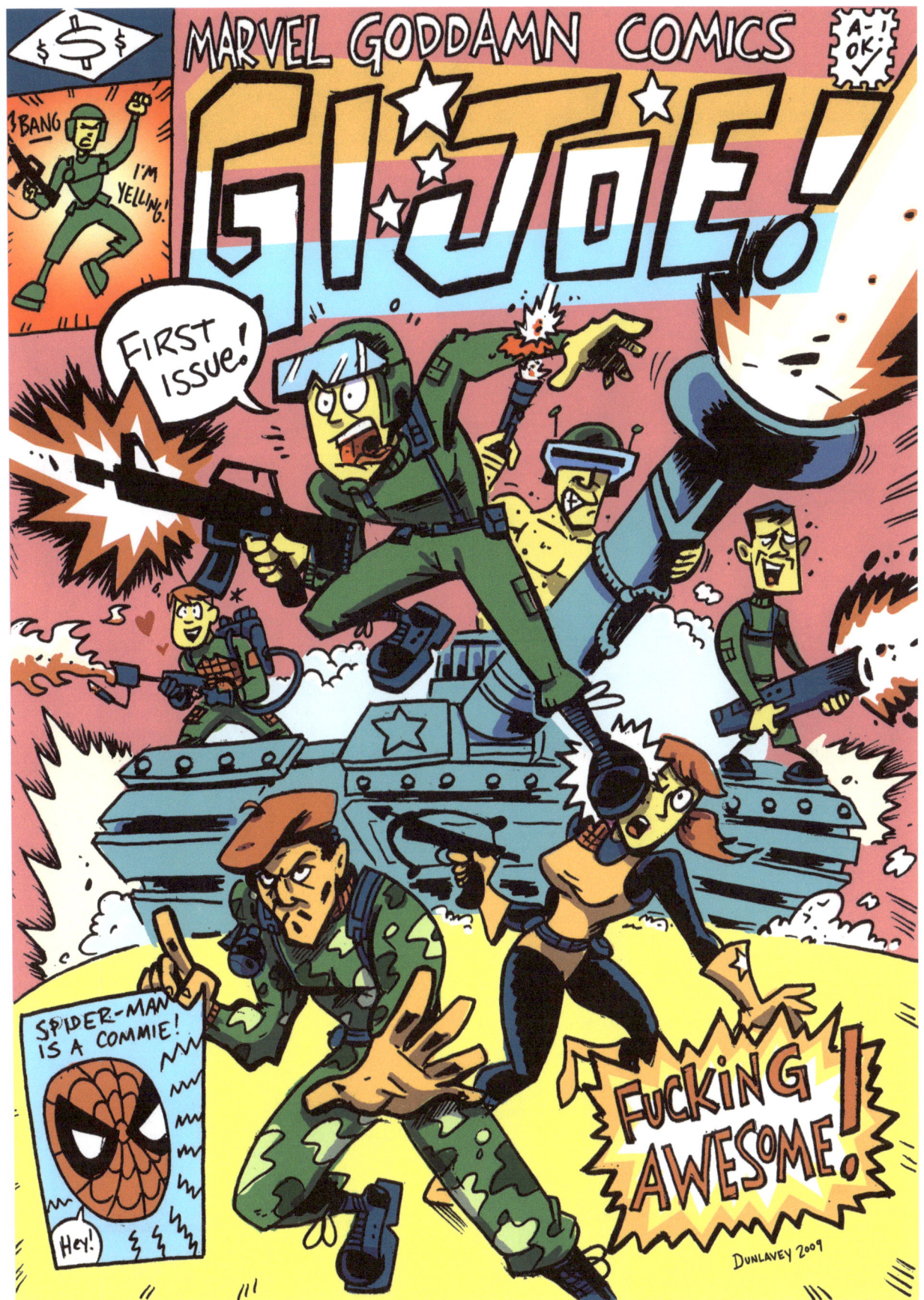

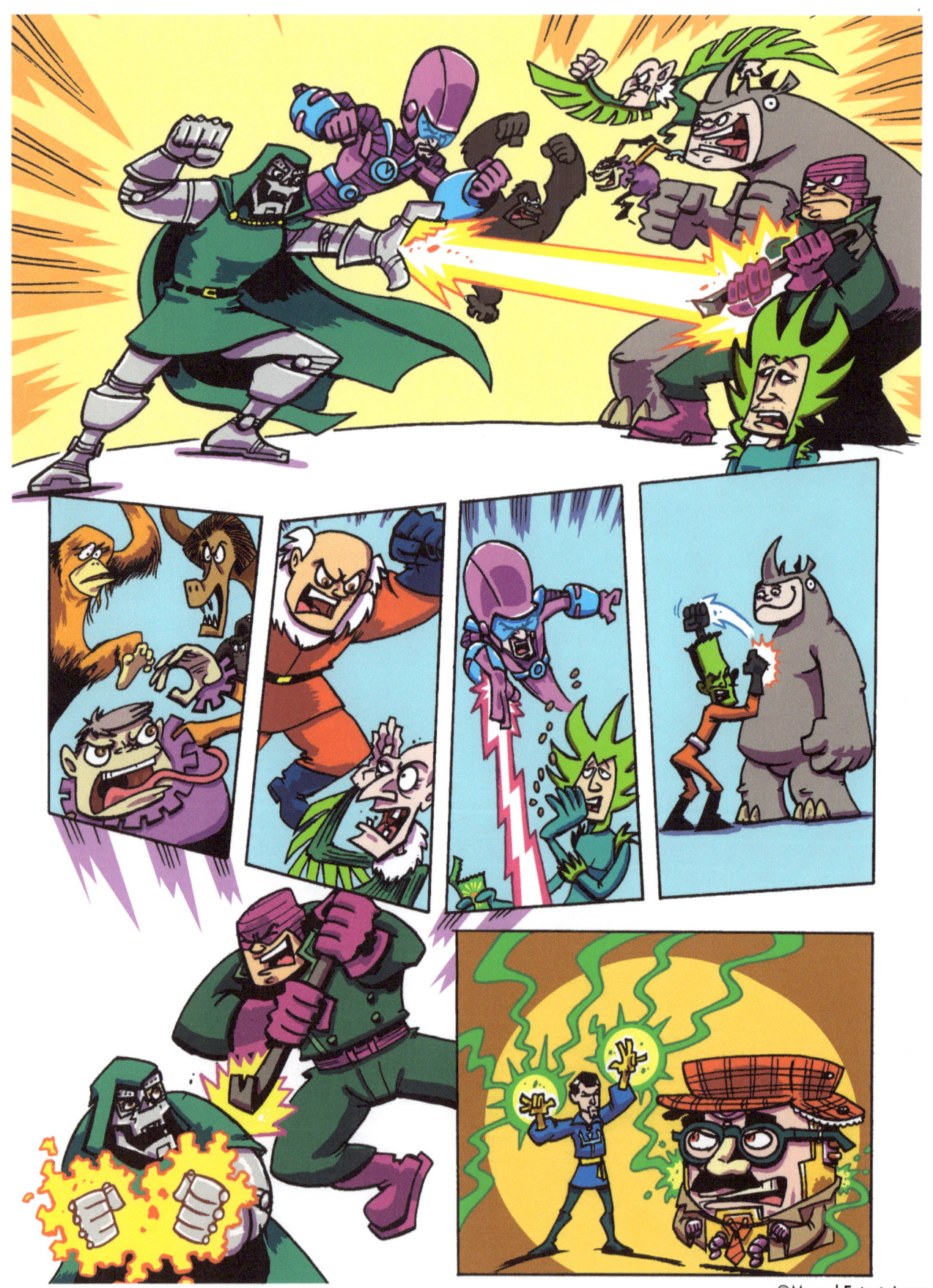

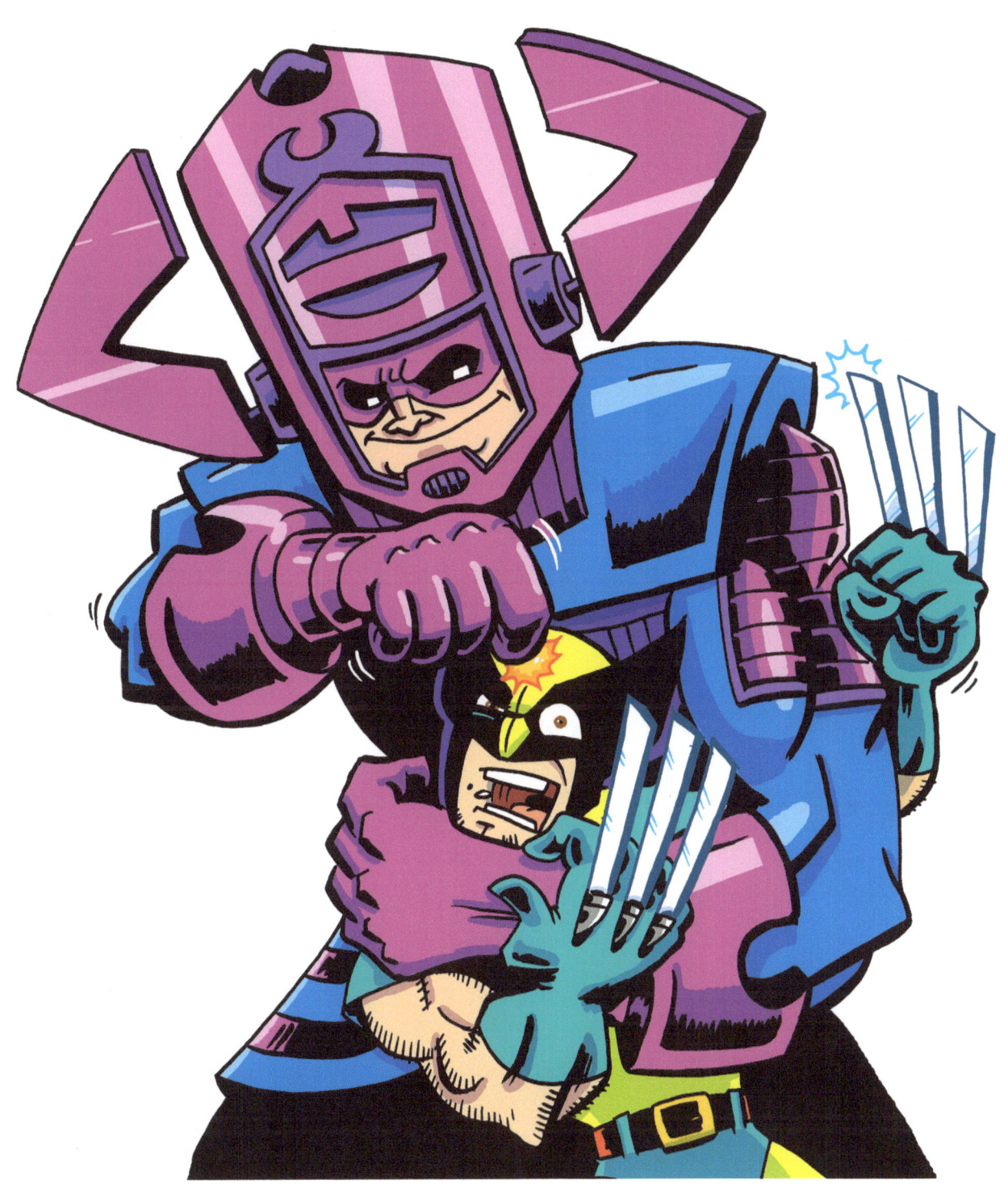

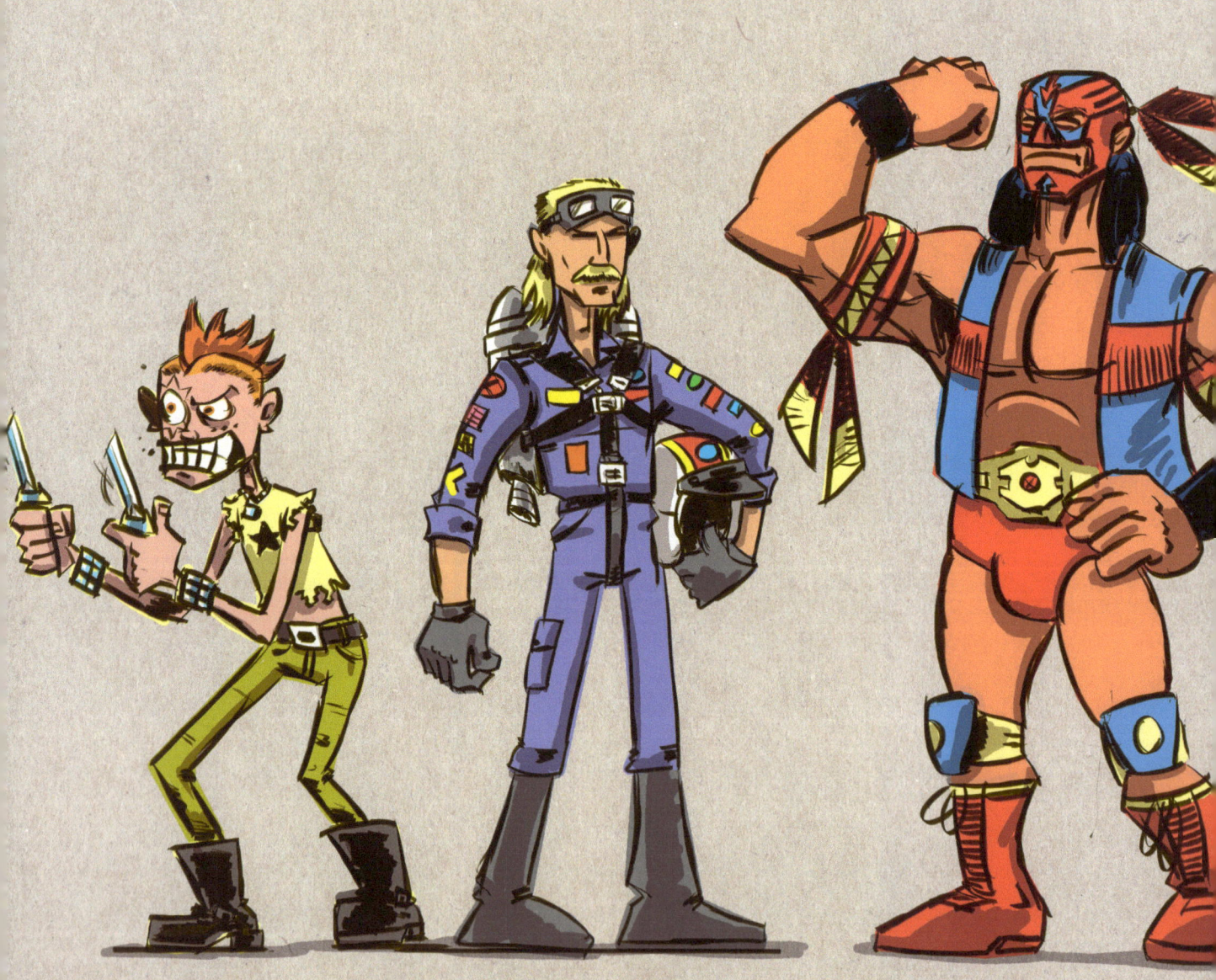

X-FORCE

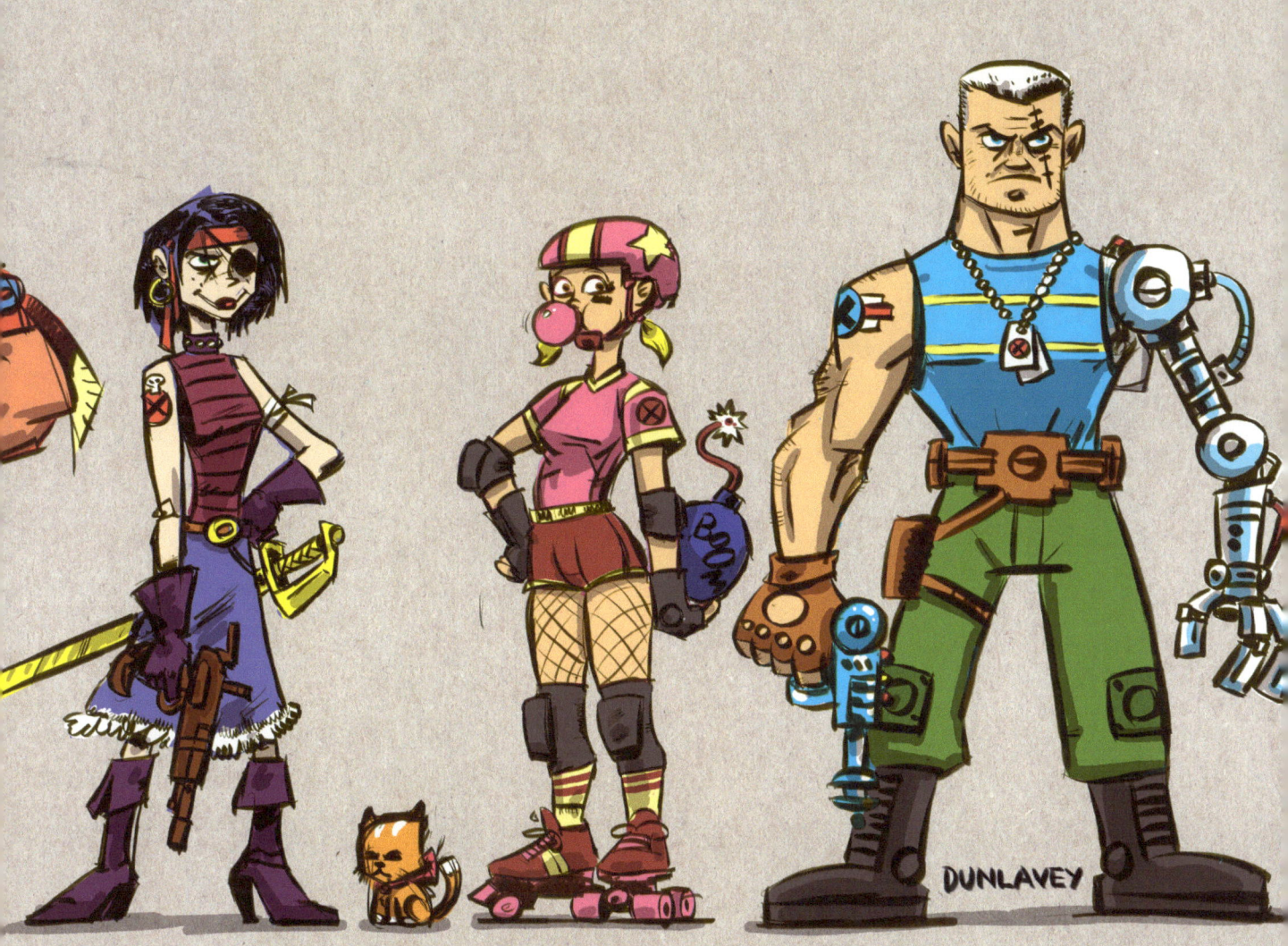

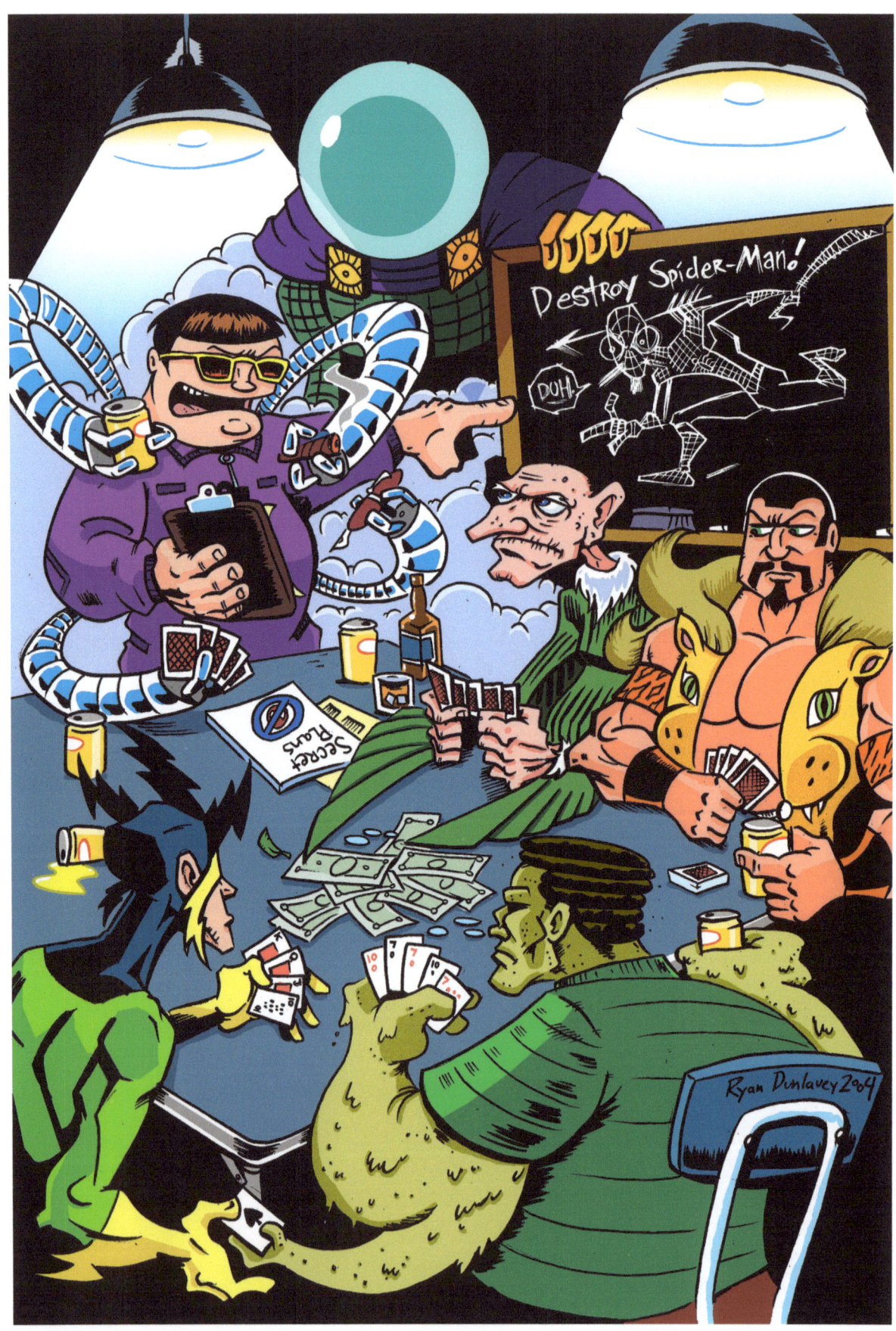

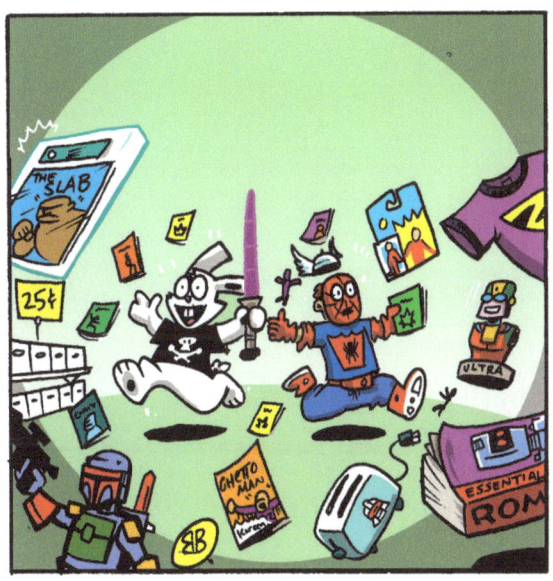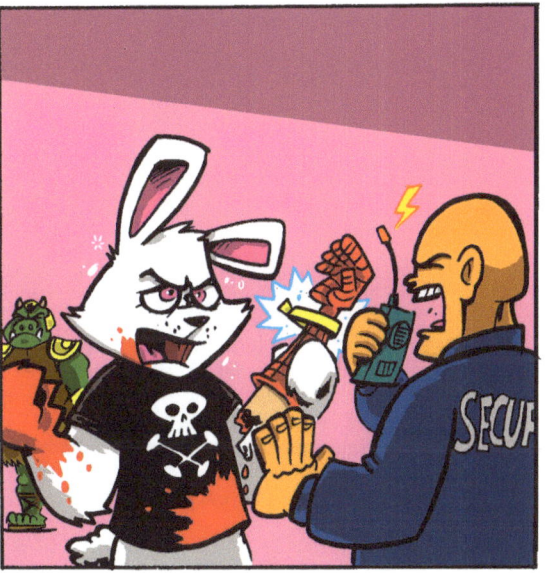

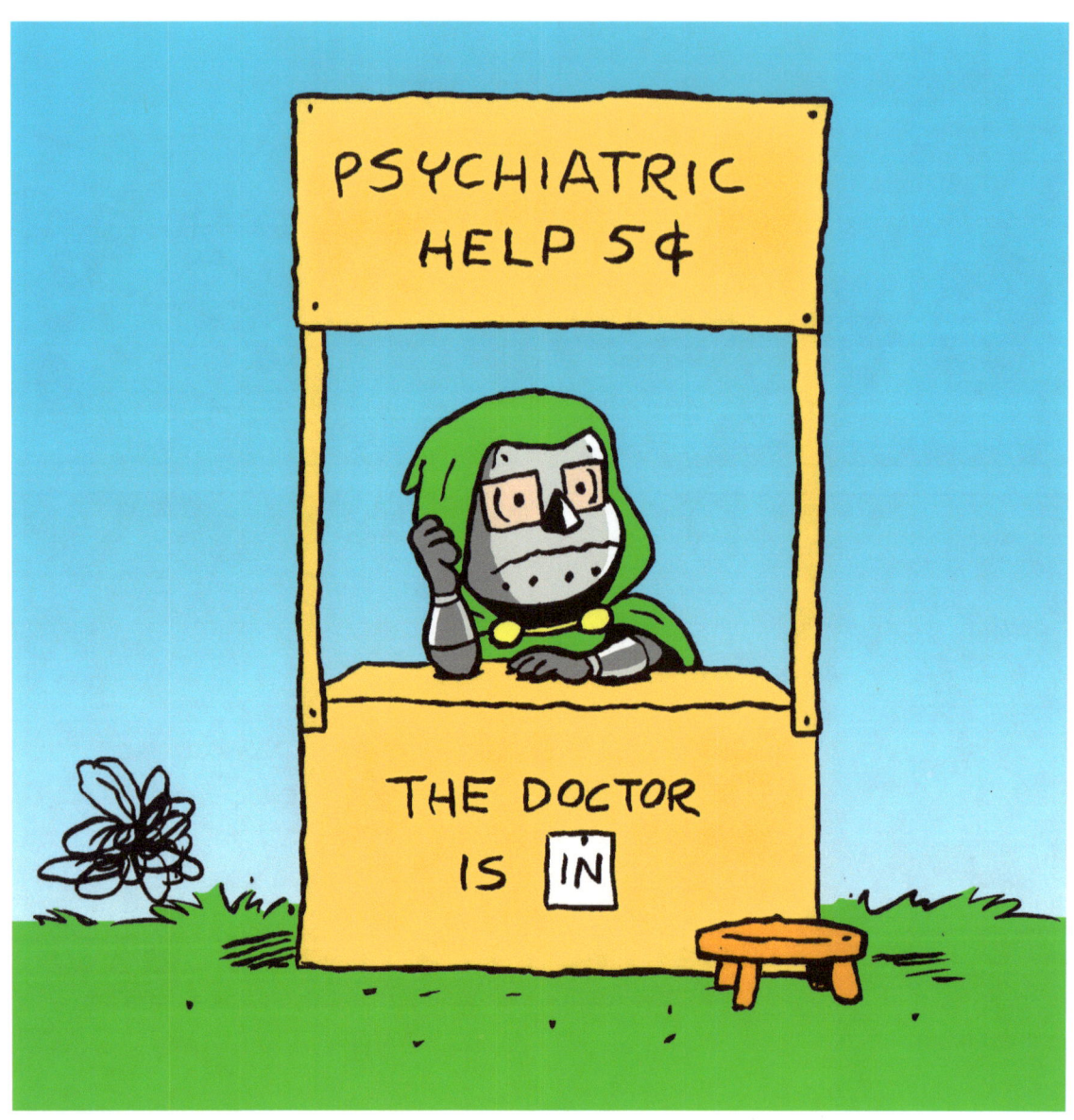

About The Artist

RYAN DUNLAVEY is a New York based cartoonist best known for being the artist of the Xeric and ALA award winning *Action Philosophers* (written and co-created by Fred Van Lente). Other works include *The Comic Book History of Comics* (also with Van Lente), *MODOK: Reign Delay* and *The Dirt Candy Cookbook* (with chef Amanda Cohen and Grady Hendrix). His illustrations and cartoons have appeared in *Royal Flush, Wizard, ToyFare, Mad, Disney Adventures* and *MTV Geek*.

Website: ryandartist.com
Twitter: @RyanDunlavey

www.ingramcontent.com/pod-product-compliance
Lightning Source LLC
Chambersburg PA
CBHW041315180526
45172CB00004B/1114